EDINBURGH

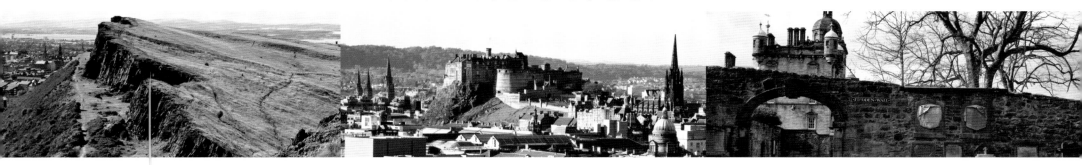

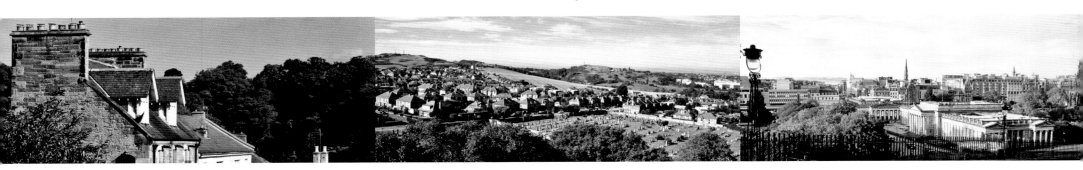

EDINBURGH

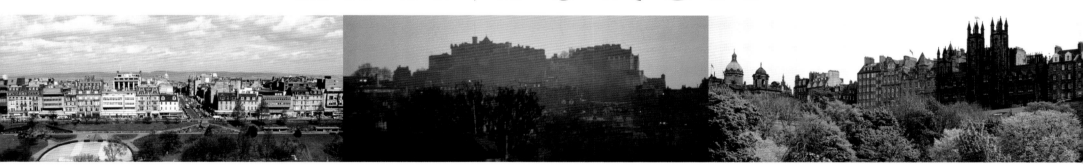

IMAGES BY LIZ HANSON
AND A SHORT HISTORY BY ALISTAIR MOFFAT

DEERPARK PRESS
SELKIRK

First published in Great Britain in 2008 by
Deerpark Press
The Henhouse
Selkirk TD7 5EY

Photographs © Liz Hanson
Text © Alistair Moffat

ISBN 13: 978-0-9541979-7-1

Design by Mark Blackadder
Edited by Kate Blackadder

Printed and bound in China through Worldprint Limited

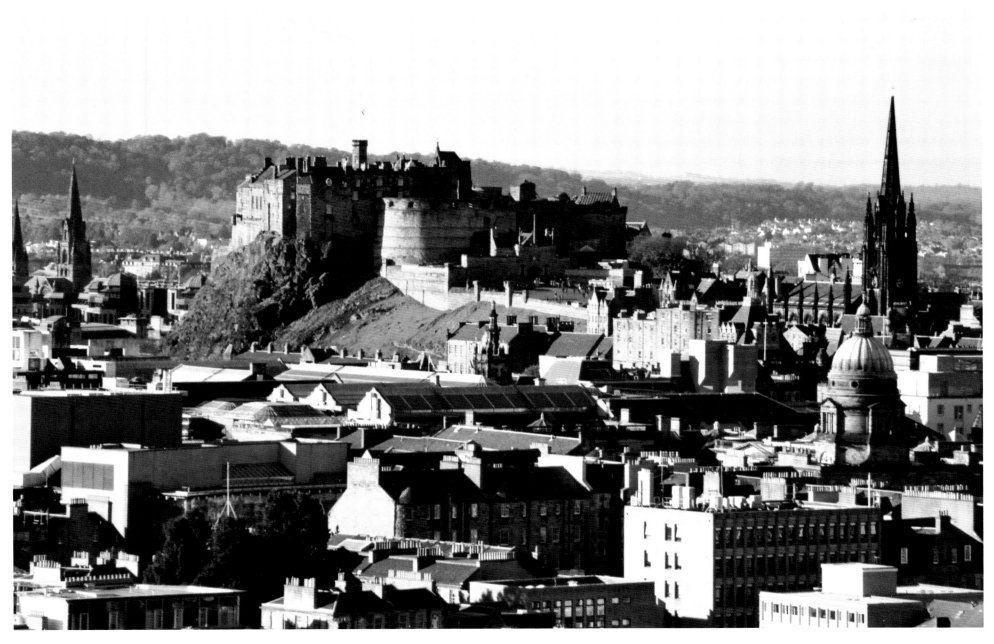

No urban skyline is as distinctive as Edinburgh's. While other cities use notable buildings or structures as visual shorthand, such as the Houses of Parliament, or the Eiffel Tower, Edinburgh has been uniquely blessed by geology. The outline of the Castle Rock with the long tail of the Old Town flowing downhill to the east, and the deep declivities of the Grassmarket/Cowgate and Princes Street Gardens/Waverley Station on either side, is immediately and universally recognisable. And it is majestic. Anyone looking west from Calton Hill sees a stunning vista, how geology and history made a city. On one side is the jagged spine of the medieval settlement and on the other the rectilinear formality of the Georgian New Town, while in the centre, leading the eye into the distance, Princes Street runs arrow-straight. Others will argue with passion for their own home-places but objective observers know that Edinburgh is without rival. It is the most beautiful city in the world.

Fire and ice made it so. More than 300 million years ago the crust of the Earth was dangerously dynamic. Volcanic eruptions tore through it, sending vast tonnages of ash and dust rocketing into the atmosphere; rivers of red and white hot magma spewed down the flanks of these black mountains; the boom of thunder everywhere rent the air and the ground shook with an elemental violence. Out of such spectacular convulsions Edinburgh was created.

Like the Bass Rock and Traprain Law, the Castle Rock was once the top of a volcanic pipe. Forced from the molten core of the Earth, magma boiled upwards and often found its way out into the air through cylindrical vents. When the eruptions settled, over millions of years, and the magma simmering in the pipes cooled, their tops formed a very hard and rounded shape, what is known as a volcanic plug. Worn down by erosion of all sorts, the Bass Rock, Traprain Law and the

Castle Rock began to assume their modern appearance.

Some time around 24,000BC the weather grew unusually severe and stormy in the north, in what was to become Scotland. Temperatures dropped and snow did not melt in the spring, staying on the hilltops through the summer. The last Ice Age was beginning. Even summer skies darkened, growing seasons shortened, vegetation died back and the animals that depended on it retreated further southwards every year. As the snow fell and the frosts deepened, the early peoples of Scotland also fled, and the landscape emptied and became silent.

At its height the Ice Age made a pitiless white vista, stretching away on every side. It was dominated by the ice-domes, huge hemispherical mountains of compacted ice, sometimes several kilometres thick. Scotland was crushed under a massive dome which formed over the ranges north of Loch Lomond.

Incessant hurricanes blew around its symmetrical slopes, and often the downward flow of wind created sustained periods of anti-cyclone, and clear, bright blue skies. It was a landscape of devastating beauty.

The ice obliterated all life and at its zenith, around 16,000BC, the glaciers reached down as far as the English Midlands and South Wales. When temperatures at last began to rise change could be rapid. Within the span of only two or three generations, the ice-sheets and the tundra to the south of them could retreat several miles. And as it did so, the impact on the environment could be dramatic. When the glaciers on the flanks of the Lomond ice-dome groaned and cracked and moved eastwards, they bulldozed our geography into recognisable features. Frozen inside these wide rivers of ice, all sorts of debris were carried along and huge boulders and pods of gravel scarted and ground across Scotland's midland valley, moving huge volumes of earth

and soft stone. When the glaciers turned to meltwater torrents, the effect could be almost immediate. River courses were broken out, deep valleys created and the character of the landscape profoundly altered.

As gravity and rising temperatures drew the Lomond glaciers eastwards, they collided with the hard rock Edinburgh castle now sits on and they were forced to divide. Having scoured and buffed the old volcanic pipe down to the bare, sheer cliffs now visible on three flanks, the ice-flow scraped out the deep ravines on either side, what became the Grassmarket/Cowgate and Princes Street Gardens and the site of Waverley Station. And crucially for the development and later nature of the city, the glaciers left a long tail in the eastern lee of the Castle Rock, the tail on which the medieval town would be built.

It was in Edinburgh that these geological processes were first recognised. In 1840 the Swiss scientist, Louis

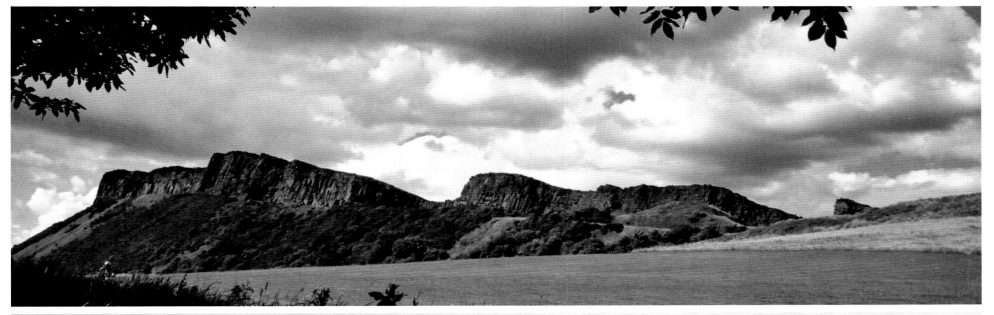

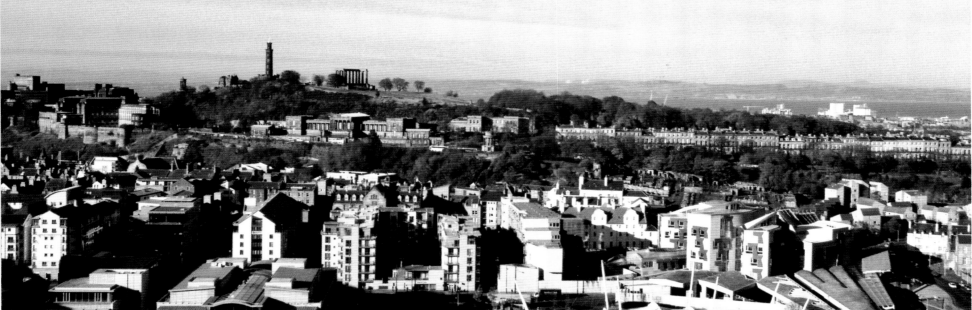

CALTON HILL FROM SALISBURY CRAGS

Agassiz, surveyed the western crags of Blackford Hill, and when he saw the scoring and gouging on the overhanging rocks and the long tail down to Liberton behind them, he declared that *this is the work of the ice*. His findings marked the beginning of the science of glaciology.

By 11,000BC Scotland was at last ice-free. A vast green canopy carpeted the land, trees grew up and over many of the hill ranges, only the wind stunting their growth. Like a temperate jungle, the great wood was dense and often shaded by thick and lush cover as the trees reached up for the light. Willow, aspen, birch, pine and hazel were the first to flourish and they remain our most hardy and adaptable native trees. Broadleaved oaks, elms and limes followed, and behind them came the animals who thrived in the abundance of the wildwood. Birds fluttered up and over the tops, their songs incessant in the long summers. Squirrels scuttled through the canopy, as did pine martens and polecats. While roe and red deer moved warily among the trees, larger, more aggressive animals cared less about stealth. Wild boar and the mighty wild cattle known as aurochs thrashed through the undergrowth. Their huge hornspreads have been found and they show these remarkable animals as giants, as big as rhinoceros. By the streams, rivers and lochs, otters and beaver fished and waterfowl lived on the rich vegetation.

Predators waited in the shadows of the wildwood. Lynxes, bears and packs of forest wolves stalked the unwary. And behind them came the most dangerous killer of all, human beings. Prehistoric men, women and their families usually preferred to travel by water and the first pioneers who came north to the Firth of Forth travelled in boats. Probably coasting up from the south, they arrived first at the mouths of rivers and streams. The outfalls of the Almond, the Water of Leith and the Esk were almost certainly among the first sites in the Lothians to be colonised by the pioneers. They were good places to live, almost Edenic, offering food from the sea, the river and the land – and security. The only tracks through the wildwood were made by animals and under the dense shade of the crowding trees, it was easy to get lost. Streams and rivers were always reliable ways to retrieve a hunter's bearings: follow the fall of the ground to a water course and then follow that until it joins a river, which will eventually find the sea and the familiar shore.

The southern hinterland of the Forth, the place now covered by the centre and suburbs of Edinburgh, was likely the hunting and gathering territory of no more than one extended family, and perhaps one or two satellite groups. But around 10,000BC it was a workable environment. Handy landmarks stood high on every side; the Pentland Hills to the south, the unmissable

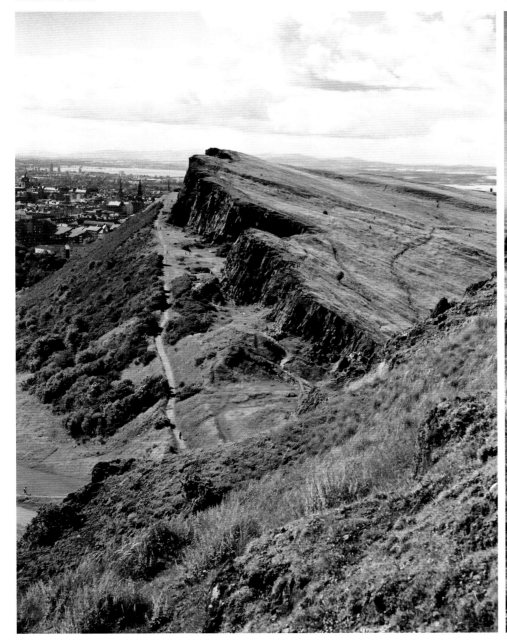

Castle Rock, Arthur's Seat, Blackford and Braid Hills, and Craiglockhart and Corstorphine Hill to the west. It was a defined homeland for the hunter-gatherer-fishers who first came north. And it may well have been a good life. Temperatures had risen close to modern levels and by 10,000BC the leaves of a thousand autumns had fallen and enriched the great wood and allowed it to nurture and sustain many animals. A wild harvest of fruits, berries and nuts was available and the long and well-fed evenings of the late summer on the banks of the Almond or the Esk might well have been pleasant as people took their ease, talked, joked and gossiped. But it proved to be a false arcadia.

Far away to the west a last, devastating legacy of the Ice Age was about to be unleashed. In the north of what is now Canada a vast freshwater lake of ice-melt had gathered. Held back only by frozen dams bulldozed into place by massive glaciers, it had begun to leak, at first only slowly. The overspill drained south, carving out the great central American river-systems of the Missouri and Mississippi. Then, very suddenly, perhaps in 36 hours, the mighty lake broke down the ice-dams to the east and with a deafening roar, it flooded into the St Lawrence Basin and the Atlantic Ocean. Sea levels rose by 30 metres overnight and the tsunamis wiped out countless coastal communities, including those on the southern shores of the Forth. Even more disastrously the huge volume of cold freshwater turned the Gulf Stream off course, pushing it away from the coasts of Northern Europe. Almost immediately the weather changed, and the deathly cold crept back over the face of the land. Storms blew, snow lay thick and long, and the pioneers who had survived the tsunamis shivered and fled south.

As the ice-dome reformed over Ben Lomond and the western mountains, the north was empty and silent once more. Around the Castle Rock and Arthur's Seat the winds whistled, and although the ice-sheets probably did not reach the eastern coasts, the tundra was sterile. For 70 generations, around 1,500 years, it seemed as though Scotland would stay locked in the grip of the ice – but then gradually the weather improved. Out in the Atlantic the clear skies had helped the ocean recover its salinity. The baleful effects of the Canadian damburst eventually evaporated and the Gulf Stream once again flowed northwards. Snow and ice melted, the trees grew high once again, and very slowly the pioneers returned. The continuous human history of what would become Edinburgh had at last begun.

As the ice melted after what historians have called the Cold Snap, between c9400BC and c8000BC, sea levels rose once more. The Firth of Forth reached as far inland as Aberfoyle, and the Clyde also encroached from the west. For several generations the land bridge connecting

BLACKFORD HILL FROM WESTER CRAIGLOCKHART HILL

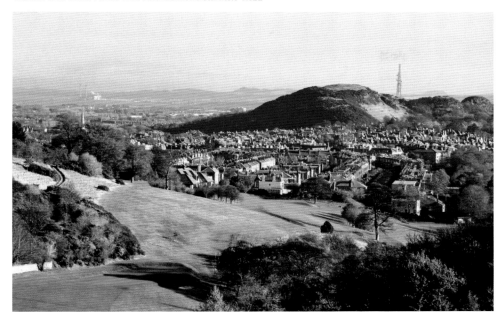

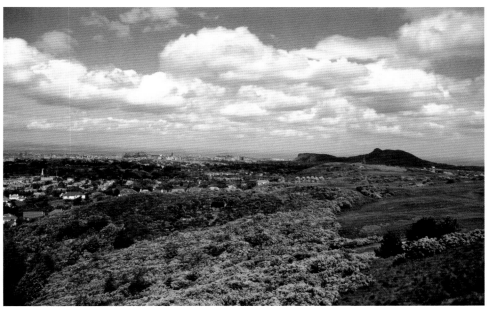

CORSTORPHINE HILL WITH PENTLAND HILLS IN SOUTH

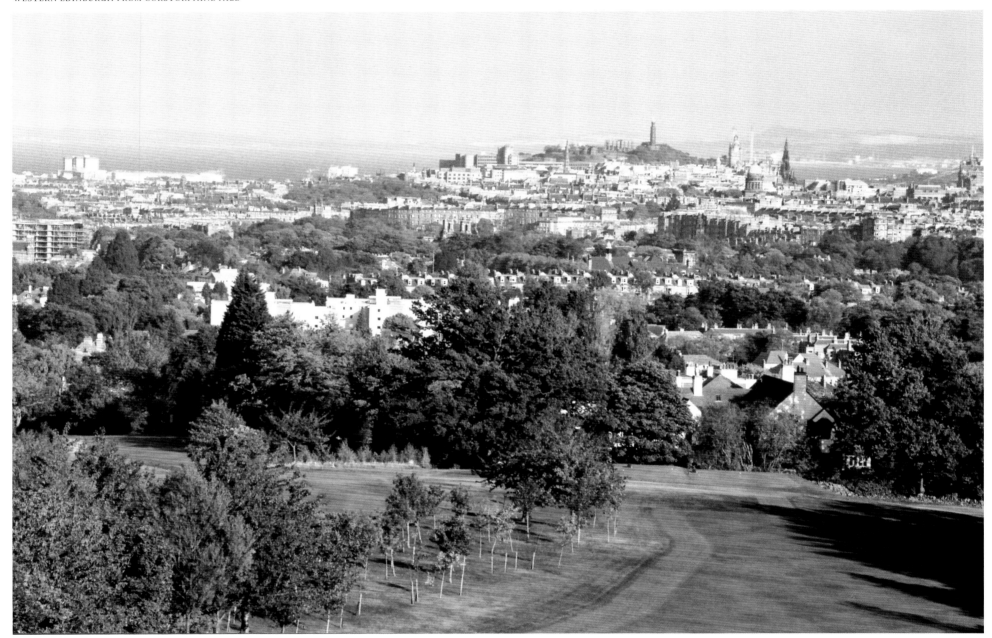

southern Scotland with the north was only eight miles wide. Much of what became the site of the city of Edinburgh was submerged under the prehistoric sea.

Nevertheless pioneers did venture north again, and soon after the ice-melt. At Cramond gossamer traces of a hunter-gatherer-fisher camp have been found and dated very early, to before 8000BC. Little more than soilstains now, it shows where a group, perhaps a family, spent time on what was probably a summer expedition. Perhaps their purpose was to fish and trap animals and preserve their meat by smoking or air-drying. Berries, nuts and fungi could also be dried or roasted and they would provide good staples through the hungry months of the winter.

With only wisps of evidence to go on, archaeologists have long believed that the early pioneers did little more than rustle the leaves as they moved through the ancient wildwood. Putting up only makeshift shelters, some of them like bender tents held up and given tension by green stakes driven into the ground (as seems to have been the case at Cramond) and lighting fires, theirs was a transient, sparse presence. But a sensational discovery in East Lothian has forced a radical revision of that view.

At East Barns Farm near Dunbar the remains of a solid and substantial wooden house have been found. It was oval in shape, about 5m by 5.8m, and surrounded by post-holes. At 55cm across they had been dug not for the stakes for a bender tent, but to take thick tree trunks or branches. Canted at angles sloping inwards, the holes looked as though they were designed to allow the trunks to meet at a central point, in a tipi shape. Traces of turf walling were found around a slightly sunken floor and the house could have happily made a snug home for six to eight people.

If archaeologists find organic matter preserved on a site, they can date it. At East Barns they came across hazelnut shells, and since they grow in only one year, they give fairly precise results. And this is what turned out to be sensational. The shells showed that the house was built some time around 8000BC, making it the oldest ever found in Britain. More than that, its discovery completely dispelled the notion of the pioneers as transients, shadows flitting through the wildwood. The effort and organisation required to build a solid wooden house more than implies ownership and the exercise of customary rights to the land around, it insists on it. And given the wide area needed to sustain even a small group living in one place (a continuous supply of firewood was only one of the most pressing logistical problems), these customary rights must have been vigorously defended.

Cities and their suburbs obliterate much of the archaeology beneath them. There was almost certainly a

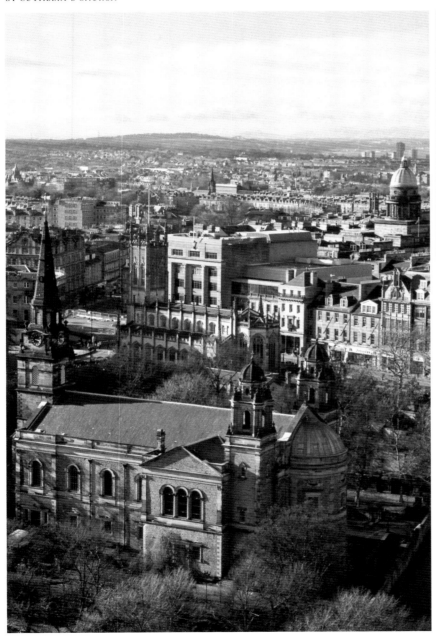

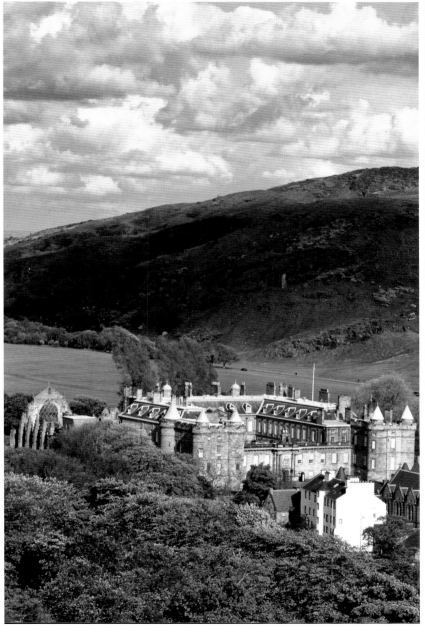

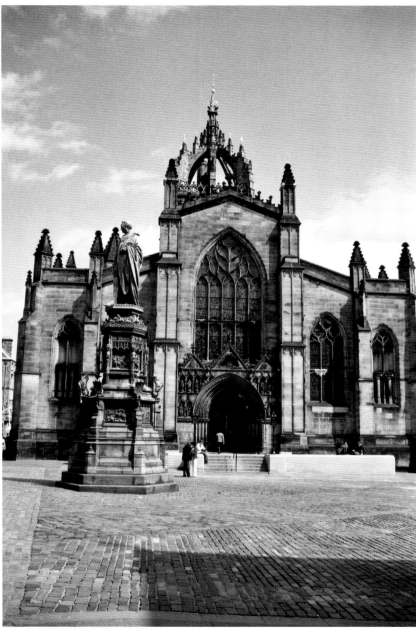

house like the great wooden tipi at East Barns in the Edinburgh area but it is highly unlikely that it will ever be found, and if it stood close to the shores of the Forth it would have been destroyed in 5840BC.

Off the coast of Norway, curving around the landmass, lies a long and very deep undersea trench. In its murky depths a geological process known as subduction takes place. It is the reason why the world's oceans and seas do not fill up with all the silt washed into them by rivers and tidal estuaries. In a subduction trench, tectonic plates meet and allow silt to slip slowly between gaps in the Earth's mantle. In 5840BC, in the Norway Deeps, subduction happened suddenly and on a huge scale. What amounted to an undersea landslip caused a massive volume of seawater to disappear – only for moments – into the vacuum created. The effect on the shores of the Forth, and all of the North Sea littoral, was startling. At breakneck speed the sea retreated. Fish were stranded as the sea-bed was laid bare and prehistoric fishermen must have thought that the gods were angry and that the world was ending. They were right. It was about to.

Having squawked into the air when the sea was sucked away, seabirds saw and heard it first. Racing towards the eastern coasts of Scotland at 500 kilometres an hour a mighty tsunami swept across the North Sea. It was already too late to run. When it smashed onto the Forth shoreline with a deafening roar, the huge wave will have destroyed everything in its deadly path, perhaps even reaching the foot of Blackford Hill and the Braids.

Archaeologists discovered the great North Sea tsunami when they found a stratum of white pelagic sand at various sites on the eastern coasts of Scotland. Only occuring far out to sea, the sand had to have been delivered by a tsunami, and the arrangement of strata above and below it allowed a date to be attached. It happened only 7,500 years ago, a reminder that prehistory saw events of extraordinary significance, and that the power of the Earth makes the doings of men and women mere details.

No precise date, or indeed the names of any individuals, can be linked to another profound historical event. At the same time as the communities of the Forth were being battered into oblivion, people who lived far to the east were changing the world. In the fertile lands between the rivers Tigris and Euphrates, much of what is now modern Iraq, wild grasses were being modified and cultivated to produce a reliable annual harvest of cereals, and animals were being domesticated. Farming was the greatest revolution in human history, and yet very little is known about how it developed and was adopted. These new ways of producing food reached Scotland around 3000BC and the area around Edinburgh was a good place to make them work.

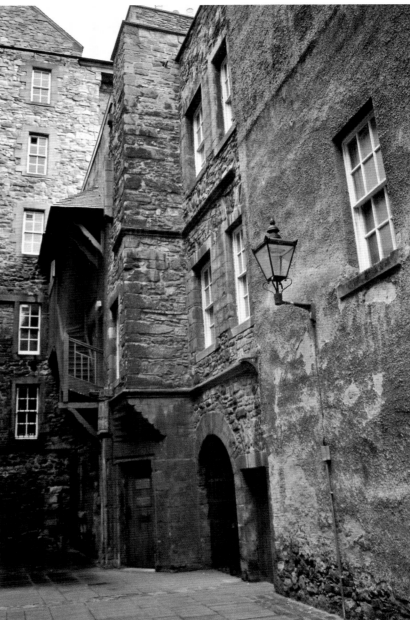

22

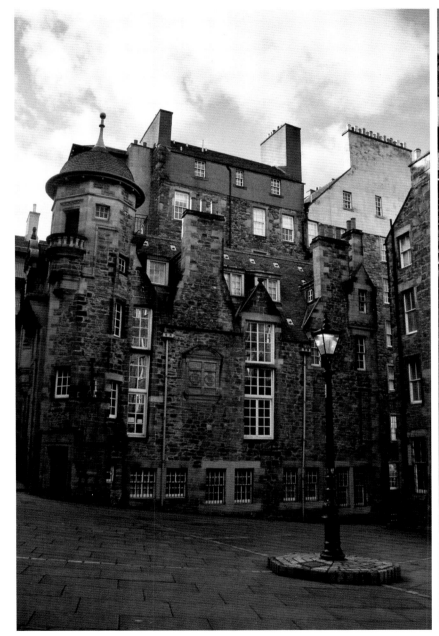

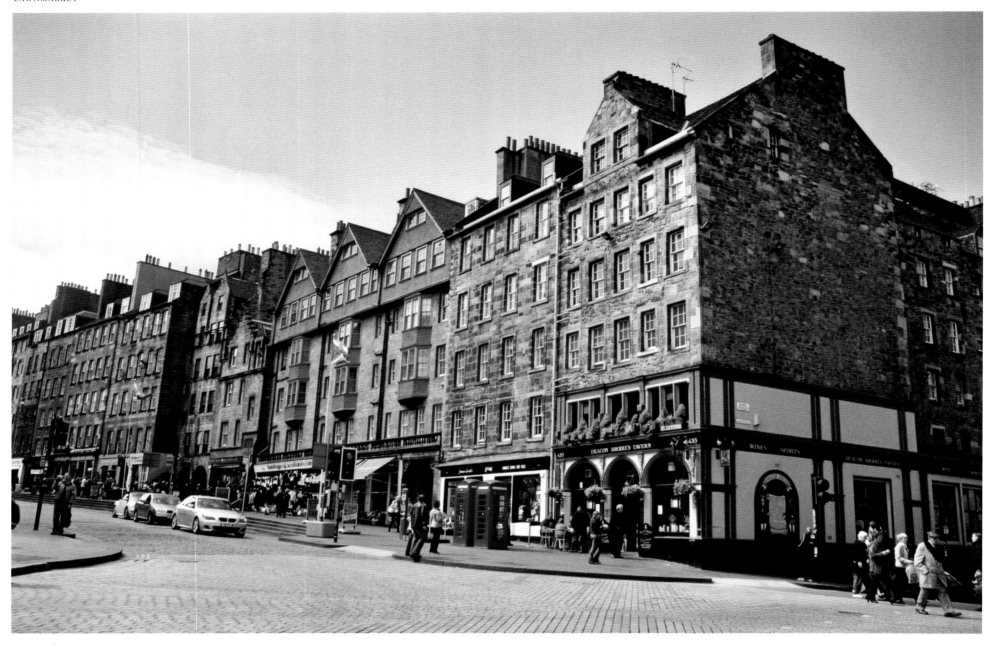

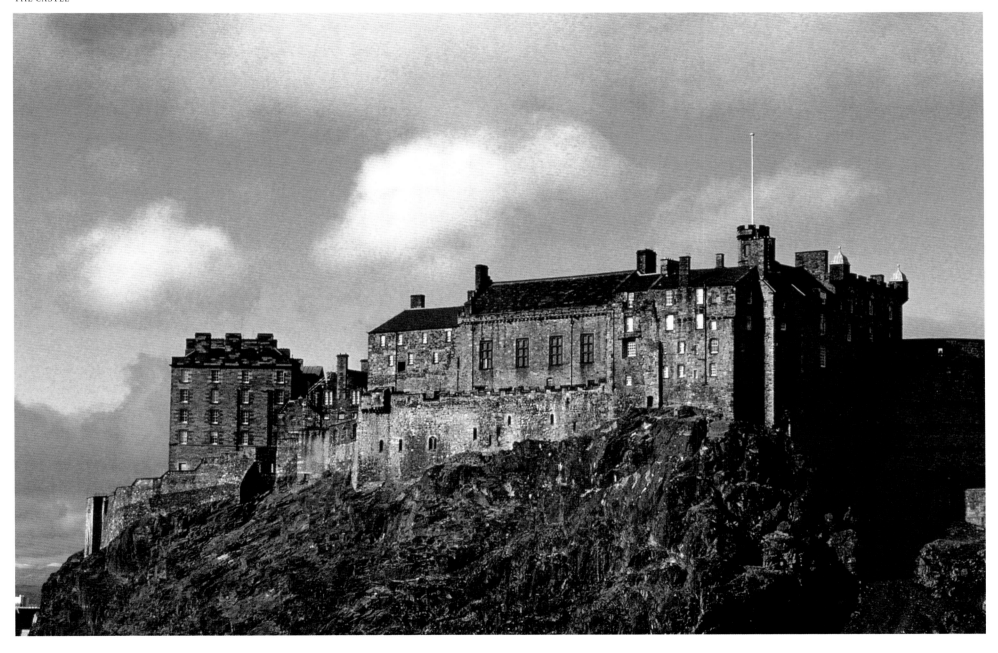

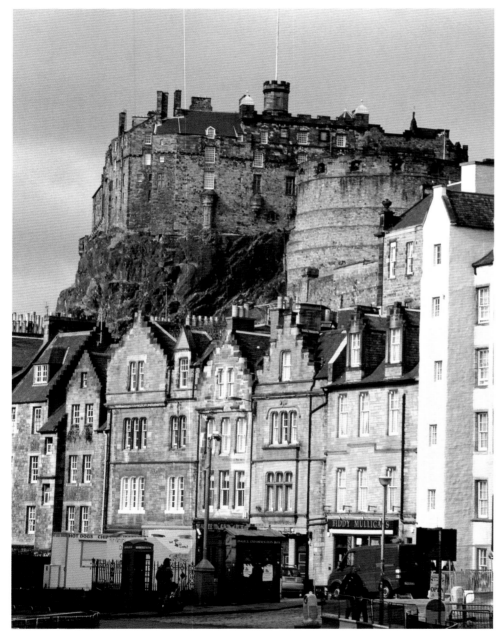

As communities began to create the small fields and pastures by clearing the wildwood, sometimes using fire, they looked for places which had good natural drainage. Until very recently, since the 18th century, valley bottoms and flat ground were often boggy and impossible to cultivate. What early farmers wanted was the sort of gently sloping ground found to the south of the Castle Rock. For example, the ridge leading from Church Hill eastwards along Strathearn Road offered inclines on either side steep enough for good run-off but not too steep to plough. Terracing was also dug and the remains of a system can still be seen on the eastern flanks of Arthur's Seat.

Farming pinned people to particular places which they worked on and improved, and in turn, that commitment fostered ideas of ownership. Competition for good land must have taken place and in the millennia following 3000BC a hierarchical society developed. In Orkney spectacular farmers' monuments have survived at Maes Howe, the Ring of Brodgar and the Stones at Stenness. They suggest a well organised society sufficiently prosperous to afford the time to build these elaborate religious structures – and also a directing hand, either a king or a powerful elite. And the houses at Skara Brae show real sophistication. There is no reason to believe that the farmers of Midlothian were less skilled or successful: the major difference is material in that they probably built in perishable wood rather than stone, and that their sites have seen more intensive use as waves of historical change washed over the landscape.

One of the most dynamic was the evolution of the warrior. As family groups coalesced into tribal societies and patriarchs established themselves as chiefs, it is likely that their supporters or bodyguards began to practise specialist military skills. When metal appears in the archaeological record of the third and second millennia BC, it is often found as weapons, not all of them designed for hunting. Swords, for example, were made for fighting.

By 1300BC to 1200BC it is likely that swordsmen rode horses. The metal parts of harness have been excavated, and by the beginning of the first millennium BC, small posses of cavalrymen might have formed the retinue of tribal chiefs, perhaps even of men who could call themselves kings. Hillforts were where they lived, at least for part of the time, and on Arthur's Seat and Easter Craiglockhart Hill stone ramparts and prehistoric ditching have been identified. Most spectacularly, at Newbridge, on the western outskirts of Edinburgh, a chariot burial was discovered. Dating from 400BC, the chariot had been set into the ground upright and intact. Usually drawn by two ponies yoked on either side of a central pole and driven by one man while

another threw javelins or fired arrows, these trim little vehicles were certainly the prerogative of a warrior elite, perhaps even kings. Burial in a chariot speaks of high status and elaborate ritual.

The highest status of all probably belonged to the man who ruled from Edinburgh's Castle Rock. And by the end of the first millennium BC it is possible to catch some fleeting sense of what he, his warriors and the society which supported them, was like. They spoke a Celtic language, but not Gaelic, as might be casually assumed. Place-names and later poetry confirm that the rulers of Edinburgh spoke a dialect of Old Welsh. From Caithness to Cornwall this was the common tongue of Celtic Britain. Gaelic was the language of the Irish and probably Argyll. The name of Edinburgh itself is Old Welsh in origin, although mysterious in derivation.

The modern name has the Anglian 'burgh' attached, a relatively late change, occuring after AD638 when the Northumbrian armies captured the Castle Rock. It means a defended settlement. The older version was Din Eidyn, and in Old (and modern) Welsh it simply denoted a fortress or a settlement. Eidyn was probably a personal name, perhaps a divine ancestor, perhaps an early king, and it may have stood for the district, the ancient equivalent of Lothian. Which allows a simple but not very informative meaning of the Fortress of Eidyn, whoever he, she or it was.

Much later, Old Welsh poetry composed in the fortress described a warrior society which saw itself in heroic terms. Glory in battle was the chief end of life for the cavalrymen of Din Eidyn as they spurred their ponies out its gates and down the slopes of what would become the medieval town. No trace of the old fortress has yet been found and it must be unlikely that the remains of its halls and stockade will ever be uncovered. But the notion that such a natural and impressive stronghold remained unoccupied until the Middle Ages is simply untenable.

In AD79 lookouts on the ramparts of Din Eidyn saw a Roman army marching towards them. Eagle standards glinted and fluttered, and flanked by screens of cavalry, and led by the Governor of Britannia, Gnaeus Julius Agricola, three legions had come to bring the north into the empire. And the king on the Castle Rock had agreed to help them do it. Known as the Votadini, later the Gododdin, the native peoples of the Lothians and Southern Scotland had probably agreed a deal with Roman emissaries. In return for a decent price for their corn (needed to feed the advancing legions), a degree of independence and a promise of protection from neighbouring kingdoms, the Votadinian kings would wave the invasion through their territory.

Agricola chose his line of march carefully, anxious about ambush, and it is likely to have followed Dere

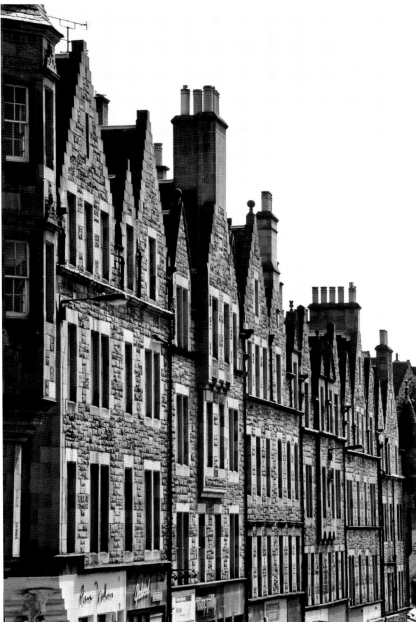

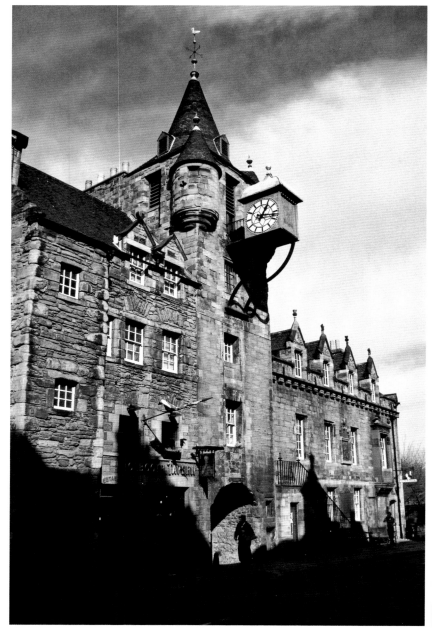

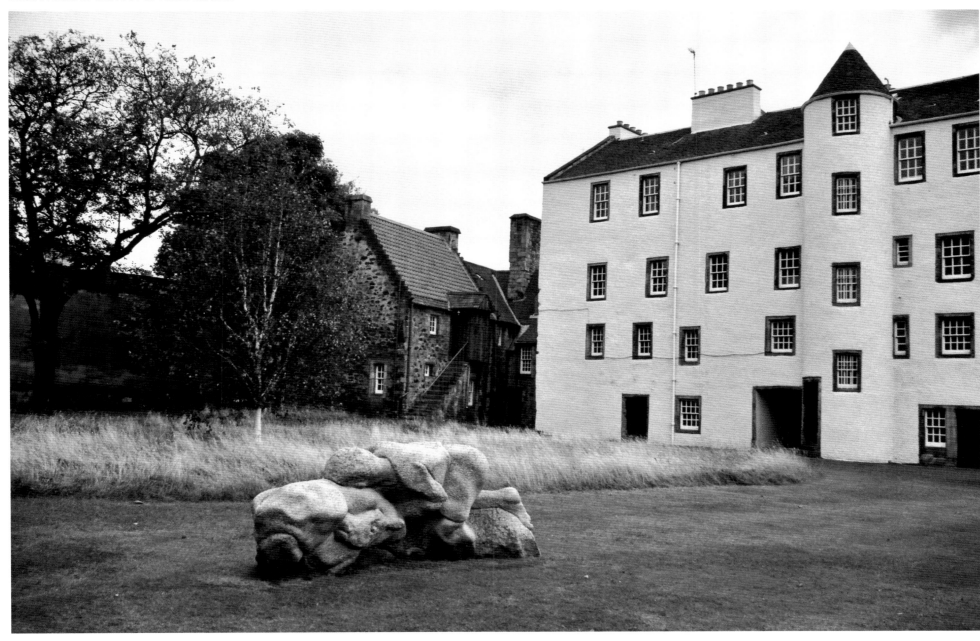

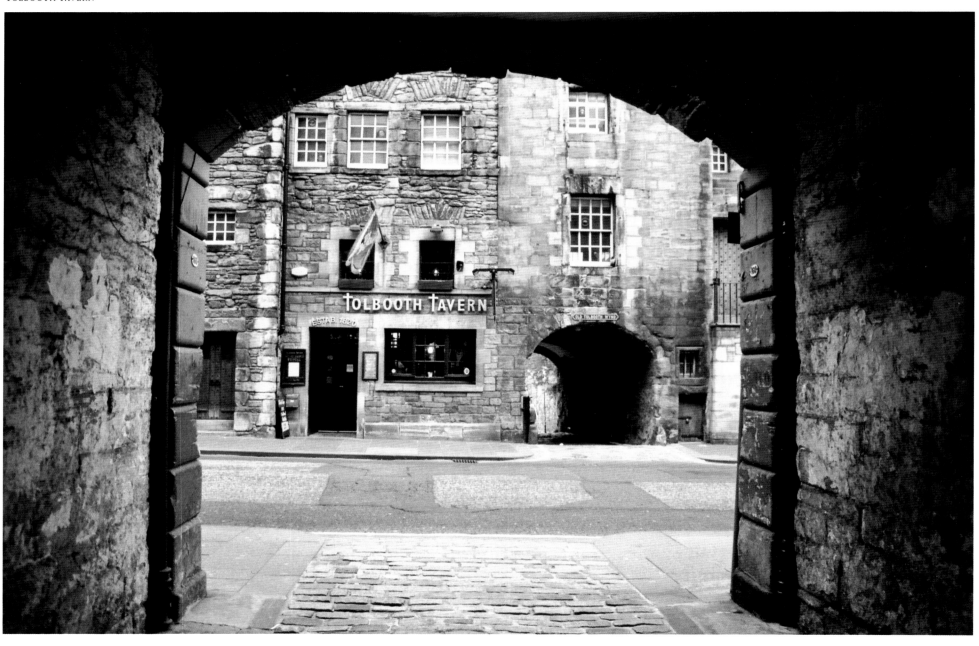

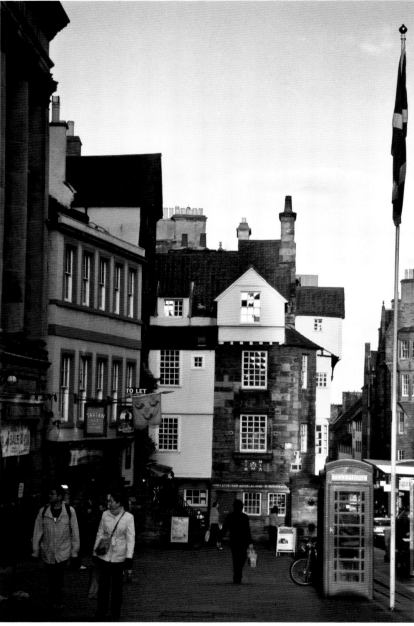

Street, the Roman road which can still be seen crossing Soutra Hill. As it nears Edinburgh, it picks up the line of the modern A7, and then descends to the road junction at Nether Liberton. Dere Street disappears after that point but historians believe that it skirted the western side of the Meadows, crossed the Water of Leith at Dean Bridge, before striking across country to Cramond and the Forth shore.

Excavations on the eastern bank of the Almond have discovered extensive remains of a Roman fort at Cramond – incidentally a near-untouched Old Welsh place-name, derived from Caer Almond, the fort on the Almond. Built in stone by AD141, it guarded the eastern flank of the Antonine Wall, a huge defensive earthwork thrown by the legions across the narrow waist of Scotland, between the Forth and the Clyde. The principia, the headquarters buildings in the centre of Cramond Fort were found around the modern kirk, and

the walls reached down to the Forth shore. Better than any of their enemies, the Romans understood the power of coordinated logistics. While soldiers patrolled the Antonine Wall, sailors and marines watched the shores of the firths at either end. It is likely that the peoples of Fife, which lay outside the empire in 141, were allies of the Votadini and the ships beached at Cramond were ready to cross the Forth to help them in any emergency and to discourage enemy naval activity against them. The ancient name of the Fife peoples, the Venicones, translates from Old Welsh as the Kindred Hounds and they were likely friendly, corn-producing satellites.

To the east of Edinburgh another Roman fort was established at Inveresk, near Musselburgh. As emperors dithered over the conquest of Scotland, their attention often attracted by crises and opportunities elsewhere in their enormous domain, the Forth forts were by turns occupied, slighted and abandoned. Towards the end of

the second century AD rebellion flared in the north, and by 208 the warlike Roman emperor, Septimius Severus, was mustering a huge army in Britain to deal with it. Perhaps the largest ever to invade Scotland, Severus' expedition travelled slowly overland while being shadowed up the North Sea coast by a supporting fleet. As the columns of the Roman vanguard reached the site of their next overnight encampment, the rearguard had only just passed out of the gates of the previous one. When the legions reached the Forth shore, it seems likely that detachments embarked on waiting transports which took them up to the coasts north of the Tay. It was an attempt to outflank the army of the Caledonian confederacy. After the death of Septimius Severus in York in 211, such expensive and ultimately ineffective campaigning ceased and the north was left to its native kings for four centuries.

The Votadini ruled from Edinburgh's Castle Rock

but it was not their only citadel. Traprain Law in East Lothian was also fortified, and Eildon Hill North in the Tweed Valley, and Yeavering Bell at the eastern end of the Cheviot ranges. All of these are singular hills standing relatively clear in the landscape and with wide views around them. High places were sacred to the early peoples of southern Scotland, but the choice of the Castle Rock and the other impressive eminences was also political. No-one in the lands around could doubt where power lay, it was to be found in the glowering forts where kings sat in judgement and where their warriors gathered.

Votadini is a Roman/Greek version of the Old Welsh name Gododdin but its derivation is not very informative, like that of Edinburgh. It means something like the Followers of Fothad, perhaps a founding king or a divine ancestor. By the end of the fifth century and the end of the Roman Empire in the west, these kings were powerful, in control of the Lothians and the Tweed Basin. They were also becoming Christians, and cemeteries of east/west facing graves start to appear in the archaeological record. Near the main runway of Edinburgh airport stands an inscribed stone and the remains of around 50 very early Christian burials. The Latin reads In this tomb lies Vetta, daughter of Victricius. These are probably the first names of people who lived in the Edinburgh area to come to light.

In 600 the Christian kings of the Gododdin faced an army of pagans. Germanic settlers, known as the Angles, had taken over in Northumberland and Yorkshire and an alliance of native kingdoms had formed to expel them. These warriors knew themselves as Y Bedydd, the Baptised, and their enemies as Y Gynt, the Heathens. Led by Yrfai, Lord of Edinburgh, the Gododdin and their allies rode south to Catterick to confront the hosts of the Angles – where they were slaughtered, only a few native soldiers surviving a terrible and savage defeat.

Momentum was with the Anglian kings and in 603 Aethelfrith routed an army of Gaelic-speaking warriors from Argyll at a place called Degsastan, probably near Addinston Farm at the head of Lauderdale, only twenty miles south of Edinburgh. By 638 the Heathens had crossed Soutra in triumph and the Castle Rock fell in that year to the Angles. No more is heard of the Gododdin and their mysterious and ancient line of kings. Their dialect of the Old Welsh language slowly slips into disuse and is now only remembered in place-names. English becomes the speech of power, the speech of the conqueror.

It was only pressure from the vigorous Pictish kingdoms of the north which prevented the Angles from overrunning all of Scotland. Decisive defeat at the battle at Nechtansmere in 685 restricted their territory to the

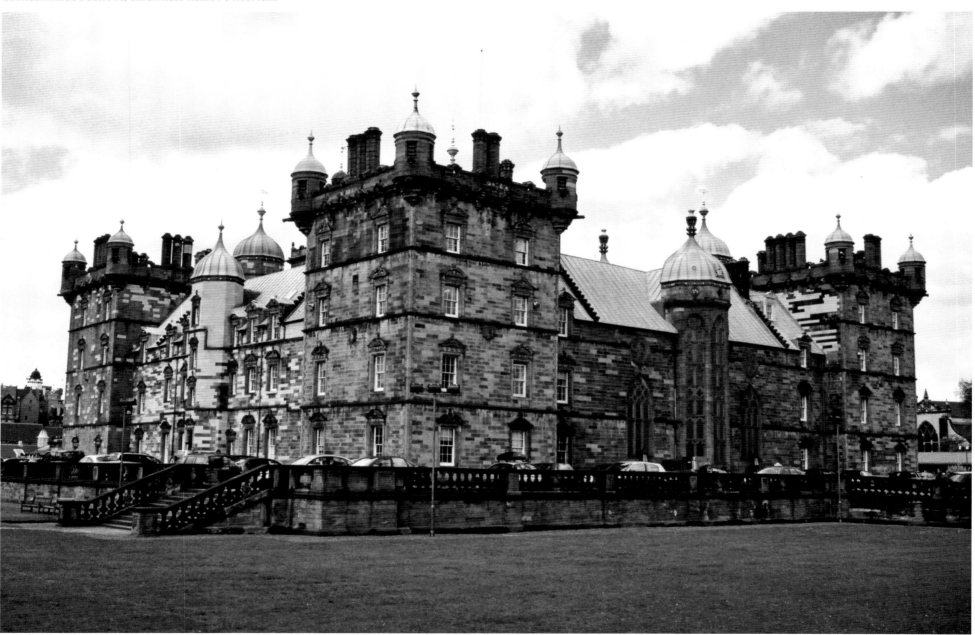

lands south of the Forth and, in the centuries afterwards, the Gaelic kings of Argyll gradually pushed them towards the Tweed Valley, down to where the modern border between England, Angle-land, and Scotland now runs.

At Carham, near Kelso, a pivotal battle was fought in 1018. Malcolm II, king of Scotland, and his Welsh-speaking ally, King Owain of Strathclyde, inflicted a heavy defeat on the Angles, the people who had become known as the Northumbrians. It secured all of the Lothians and Edinburgh and much of the Tweed Valley. But not before English had replaced Old Welsh as the language of the south-east of Scotland and the peoples who lived around Edinburgh.

The Northumbrians left a religious legacy still visible in the heart of the city. At the foot of Lothian Road, where it joins Princes Street, stands St Cuthbert's Church, and the dedication offers a hint of its great antiquity. Originating in the Borders, taking holy orders at the monastery at Old Melrose and rising to become Bishop of Lindisfarne, Cuthbert was a talismanic figure for the Northumbrian kings and it was not long after his death in 687 that he came to be revered as a saint. Durham Cathedral is his great monument, but there are many ancient dedications to his exemplary life in the area once ruled by his patrons. Under the relatively modern church (1892-4) traces of six earlier buildings have been found. Dating to the eighth century, St Cuthbert's is probably older than the High Kirk of St Giles' (it was only a cathedral between 1633 and 1639 when Charles I tried to impose bishops on the kirk) in the centre of the Old Town. It was first recorded in 859 and refounded and dedicated to St Giles by Alexander II in 1120.

The presence of an early church in what is now the High Street, set some distance from Edinburgh Castle, implies a settlement around it. No archaeology has yet been found and any wooden buildings would be difficult to detect, and in any case the village probably more resembled the scattered shape of a Highland township than a concentrated group of houses. The oldest, clearly visible structure in Edinburgh is St Margaret's Chapel. It stands at the highest point inside Edinburgh Castle. Its saint was Queen of Scotland until 1093, the wife of Malcolm III Canmore, but the chapel or, more correctly, the small church, was probably commissioned twenty or so years after her death by her son, David.

The sixth son of Canmore and Margaret, this remarkable man could never have expected to become king. Raised at the court of Henry I of England, he imbibed Norman culture, travelled to France and by 1113 was a substantial landowner. In addition to the English earldom of Northampton, he had inherited a vast swathe of territory over the south of Scotland from his

brother, Alexander II. In order to develop his holdings, David began to bring communities of monks over from northern France, the first foundation being at Selkirk.

When he became king in 1124, David invited more monastic houses to set up in Scotland, and also started formally to establish towns. In that year his charter for the foundation of Holyrood Abbey talked of *meum burgum*, his town of Edinburgh. As they surveyed the proposed site of the king's new town, royal officers had a profound and enduring impact. The area, the regality of Edinburgh was set at 143 acres, ample for the time but later to produce immense architectural problems – and solutions. So that many craftsmen and shopkeepers could enjoy a frontage onto the market street, the building plots were narrow, perhaps only 25 feet, but also very long at 450 feet. Pegged out by men called liners, they were steep, descending to the ravines on either side. The plots were usually divided into forelands, with a street frontage, and backlands behind them. The latter were reached by closes and these sometimes still bear the names of the people who lived in the town in the medieval period. When two or more plots, known as burgages or tofts, were owned by one person and a double frontage was built, the backlands were reached by a pend, a vaulted passageway with an arch at each end. Aristocratic or wealthy town dwellers preferred to live in the backlands, away from the racket and the squalor of the street, and the likes of Tweeddale Court and Lady Stair's remember the time when the quality lived up a close.

David I's town seems to have been laid out around the old church of St Giles. What is now the Castle Esplanade was originally much too narrow for housing and in any case the garrison would have been happy to have a clear, uncluttered field of fire from the ramparts. It is said that the gatehouse is a bow-shot from the first building on Castlehill. It was only in 1753 that the narrow ridge was broadened into a parade ground using the earth from the foundations of what is now City Chambers. The Esplanade was widened again in 1816 and railings added.

Castlehill, the westernmost element of the Royal Mile, recalls the narrow ridge and was probably not an important part of the medieval town. Where the street broadens dramatically is at the Lawnmarket. Derived from Land-market (an echo of the longer vowels of early Scots pronunciation – Lawnd was how land sounded), the place where farmers brought produce from the landward area to sell, the street was laid out to accommodate stalls and booths. It narrowed significantly at St Giles, the place where the Old Tolbooth intruded and made the High Street only 12 feet in width. This ramshackle building was the centre of civic and commercial life in medieval Edinburgh and even later.

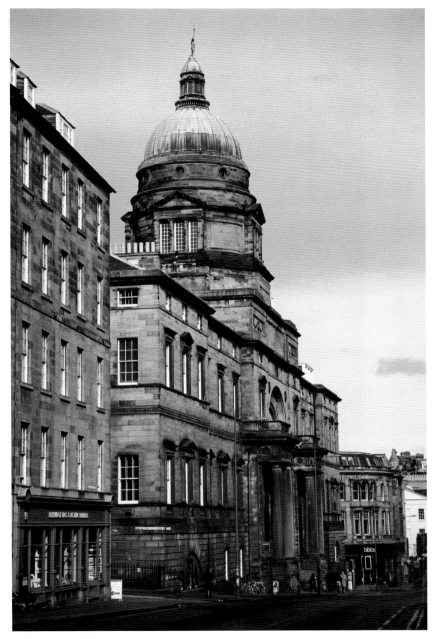

42

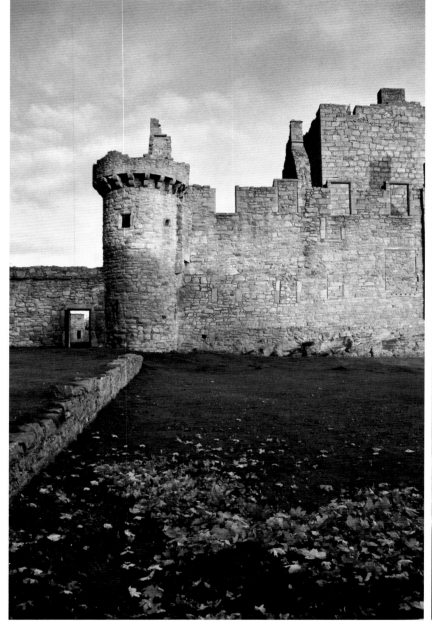

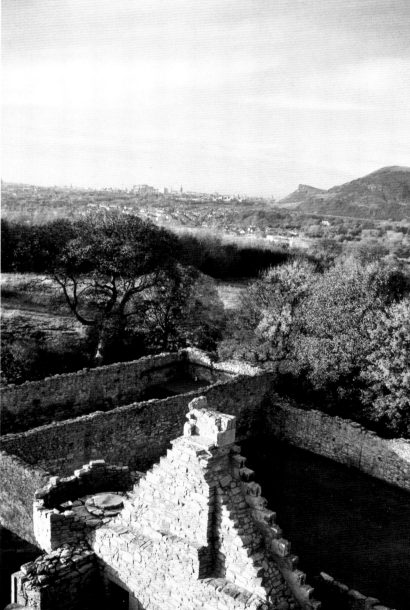

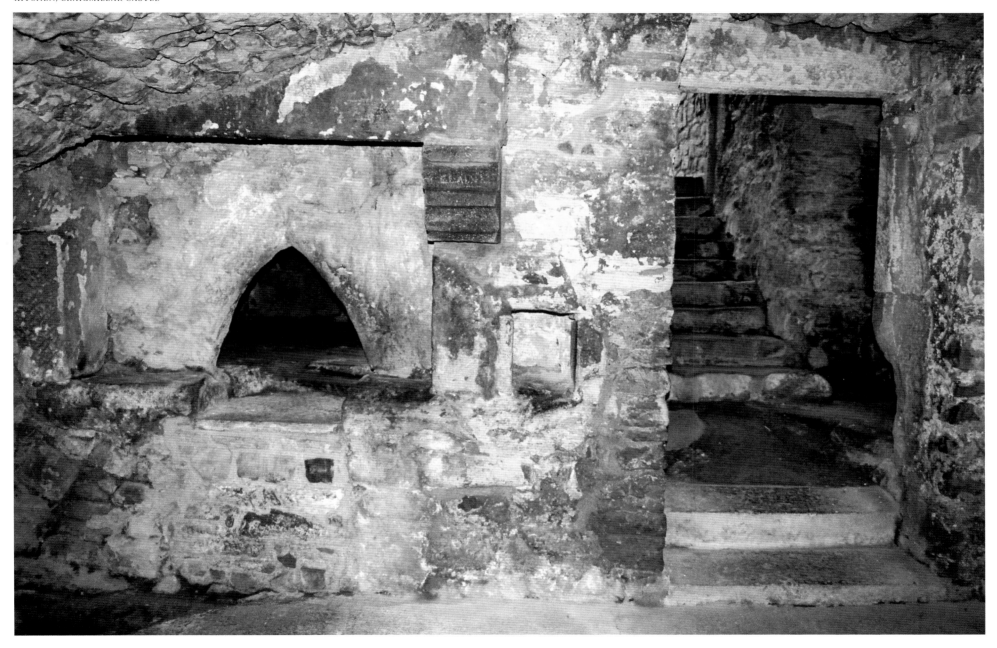

44

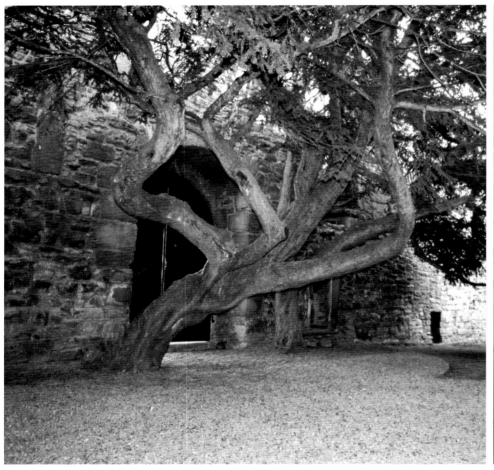

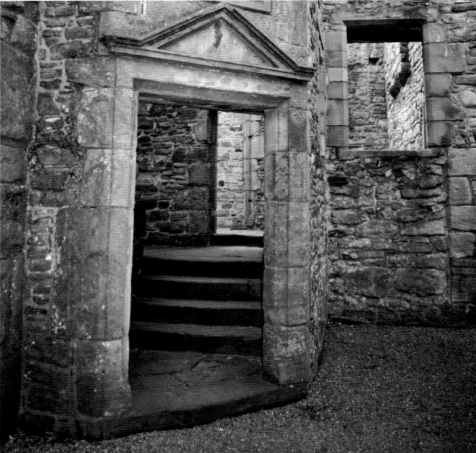

Demolished in 1811 and 1813, it was where tolls were paid by merchants and stallholders, where the nightly curfew bell was rung and where town meetings and law courts were held. Eventually it became a jail and a place of execution. The site of the Tolbooth is marked by a heart-shaped design picked out in coloured cobbles, near St Giles. It is also a reference to Sir Walter Scott's novel, *The Heart of Midlothian*, which is set in the Old Town of Edinburgh and features the Tolbooth as a location. Local people sometimes surprise passing visitors by turning and spitting on the design, often without pausing. They do it for luck and it is said that when prisoners were at last released from the filthy cells of the old prison, the first thing they did was to spit in an ill-defined gesture of defiance.

Beyond the Tolbooth the High Street widened again before reaching its end at the east gate, the Netherbow Port. The layout of medieval Edinburgh's spinal street resembled an egg-timer and off this pinched waist, around 200 closes and pends ran downhill on either side.

As the town grew, some of the closes evolved into specialist markets which traded every day. Fleshmarket Close and Fishmarket Close are the most obvious and the grain and meal markets were held nearby, behind St Giles. And around the Tolbooth and the old kirk, luckenbooths huddled. Simply meaning locked stalls, they usually sold more valuable items, and merchants with street frontages on the Lawnmarket and High Street were encouraged to build arcades over the entrances to their shops.

The fall of the ground in Edinburgh, and the increasingly crowded nature of the site began to force expansion upwards. By 1400 it was the largest town in Scotland with more than 350 buildings loosely described as houses and a population of 2,000 souls. By 1500 the High Street was continuously built up and the Grassmarket and the Cowgate had become part of the town. Pressure on space forced the tenements to add more and more storeys. Buildings with six or seven floors were not uncommon and visitors to Edinburgh were awestruck at their height. By the 17th century the Great Tenement, which stood near what is now the Signet Library, had climbed to a dizzying and dangerous fourteen floors.

In his novel of 1815, *Guy Mannering*, Sir Walter Scott used his own experience of the Old Town, just as the vertiginous tenements were about to pass into history:

It was long since Mannering had been in the street of a crowded metropolis, which, with its noise and clamour, its sounds of trade, of revelry, and of licence, its variety of lights, and the eternally changing bustle of its hundred groups, offers,

46

by night especially, a spectacle, which, though composed of the most vulgar materials when they are separately considered, has, when they are combined, a striking and powerful effect on the imagination. The extraordinary height of the houses was marked by lights, which, glimmering irregularly along their front, ascended so high among the attics, that they seemed at length to twinkle in the middle sky. This 'coup d'oeil', owing to the uninterrupted range of buildings on each side, which, broken only at the space where the North Bridge joins the main street, formed a superb and uniform Place, extending from the front of the Luckenbooths to the head of the Canongate, and corresponding in breadth and length to the uncommon height of the buildings on either side.

The difficulties of Edinburgh's site were obvious, and were not helped by the exigencies of politics. To protect Edinburgh from a feared seige in 1460, James II had a dam built at the east end of the site of Princes Street Gardens and the Nor Loch filled up. Dark and filthy, it clearly prevented expansion to the north. Elsewhere the growing landed wealth of the church had the same blocking effect.

In the east David I had founded Holyrood Abbey and the Augustinian Canons had established their own town, the Canongate. To the south the convents of Blackfriars and Greyfriars (Dominicans and Franciscans) held land they were not willing to give up. In 1513, in the panic which followed the king's death in the catastrophic defeat at the battle of Flodden, a wall was hurriedly thrown around Edinburgh and this effectively stifled any expansion beyond it. The Flodden Wall survives in places, at the Pleasance and south of the Grassmarket, and it shows how small the medieval city was.

The high buildings off the High Street, the Grassmarket, and their closes and pends, were known as tenements. All manner of people, poor and wealthy, titled and anonymous, could share a common stair and the survival of many tenements, rebuilt over centuries, has maintained a defining tradition. Many still live in the centre of Edinburgh. Unlike other great cities, it does not see those who work there leave for the suburbs to be replaced by those coming into town to eat, drink and make merry. In the period of Victorian expansion, architects imitated the style of the medieval tenements and created areas of dense settlement immediately to the south of the Old Town. The long rows of two-up and two-down terracing so typical of English cities is not seen in Edinburgh until the outlying suburbs, mostly built in the 20th century. Several thousand people still live and work in the middle of the city and something of the domestic, human-scale of the Old Town (and the New Town) still survives.

When David I became king in 1124 and for centuries afterwards the royal court moved around

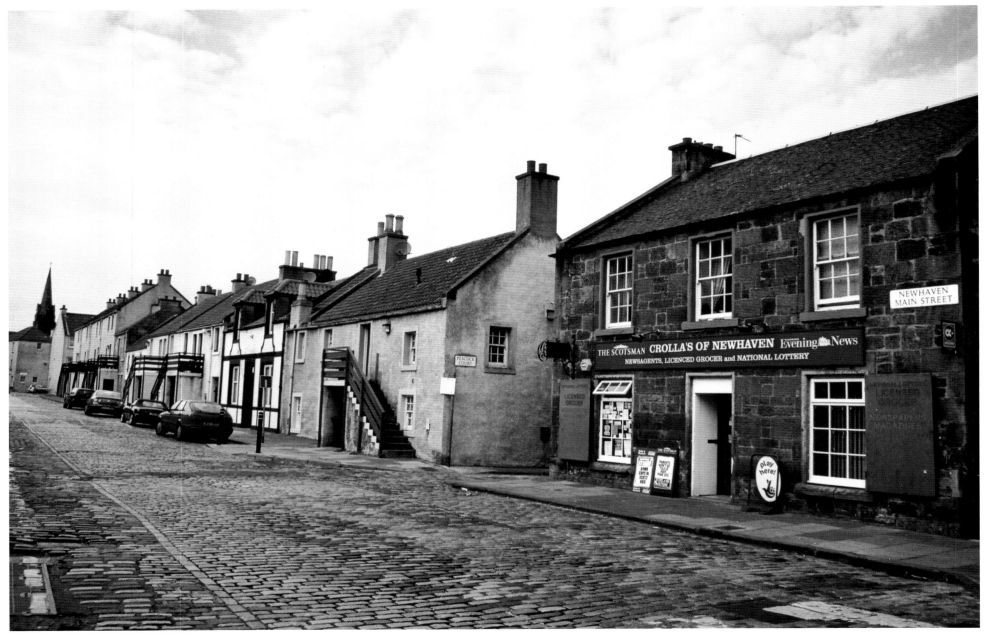

Scotland. There were royal castles at Roxburgh, Berwick, Stirling and a palace at Dunfermline much used by St Margaret and Malcolm III Canmore. The court packed its luggage into carts and trundled the muddy tracks because it had to. Rents and services owed to the king were often paid in kind and these had to be ingathered and consumed, and the produce of the huge royal estates could be made to sustain the household in this way. From its foundation Holyrood Abbey had royal apartments at the king's disposal, and during the medieval period these expanded and elaborated. Perhaps because it was windy and cold, and at the end of a steep climb, Edinburgh Castle was not a favourite residence. Kings preferred Stirling, and if they had to come to Edinburgh, they usually quartered with the Augustinian canons at Holyrood.

In 1143 David I allowed the abbey to set up its own town, the Canongate. It remained separate from Edinburgh until 1643 and its last vestiges of independence were not abolished until 1856. Because it was adjacent to the royal residence, noblemen built houses in the Canongate and these aristocratic associations survive in the shape of Queensberry House, Moray House, Panmure House and Acheson House. The little town was not walled or defended and its original open, less built-up character can still be glimpsed. The Canongate Tolbooth fared better than Edinburgh's and still stands, while several closes remember the town's role as a staging post for coaches and their horses. Preferring to avoid the steep climb up the High Street at the end of a journey, travellers and their transport lodged at the White Horse Inn, at White Horse Close and in the other old hostelries which still line the main street.

The king also gifted the right to build and make money from mills on the Water of Leith to the Augustinian Canons at Holyrood, and the district of Canonmills was the busiest location. And Holyrood Park, particularly the area nearest the Canongate known as the Queen's Park, was a handy place to graze animals and gather fuel. David I gave a wide tract of wild and wooded land to Edinburgh for the same purposes. The Burgh Muir lay to the south of the Burgh Loch (later drained to become The Meadows) and it reached the foot of Blackford Hill. From east to west it stretched for three miles from Duddingston to Morningside. Now it is almost entirely overlaid with the suburbs of south Edinburgh but in the 12th century documents relating to Holyrood Abbey it was a 'great forest full of harts and hinds, foxes and suchlike manner of beasts'. David I and his descendants were enthusiastic huntsmen, and around their properties the chase was often possible. Buildings began to go up on the Burgh Muir in the late 16th century, mainly the houses of local lairds, and now its

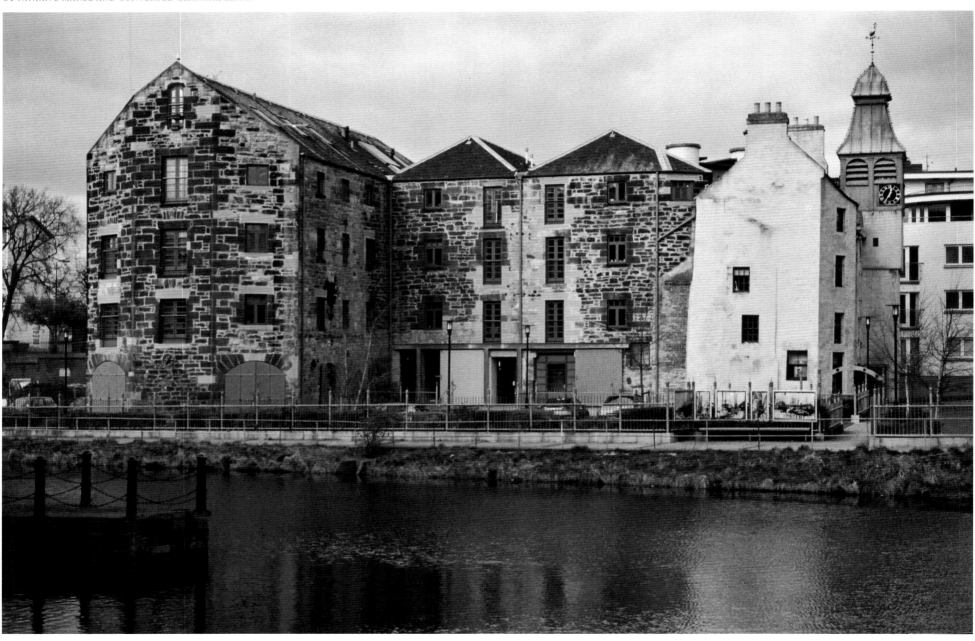

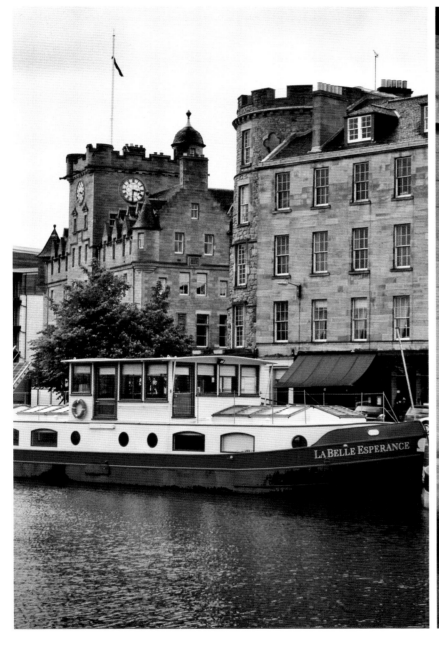

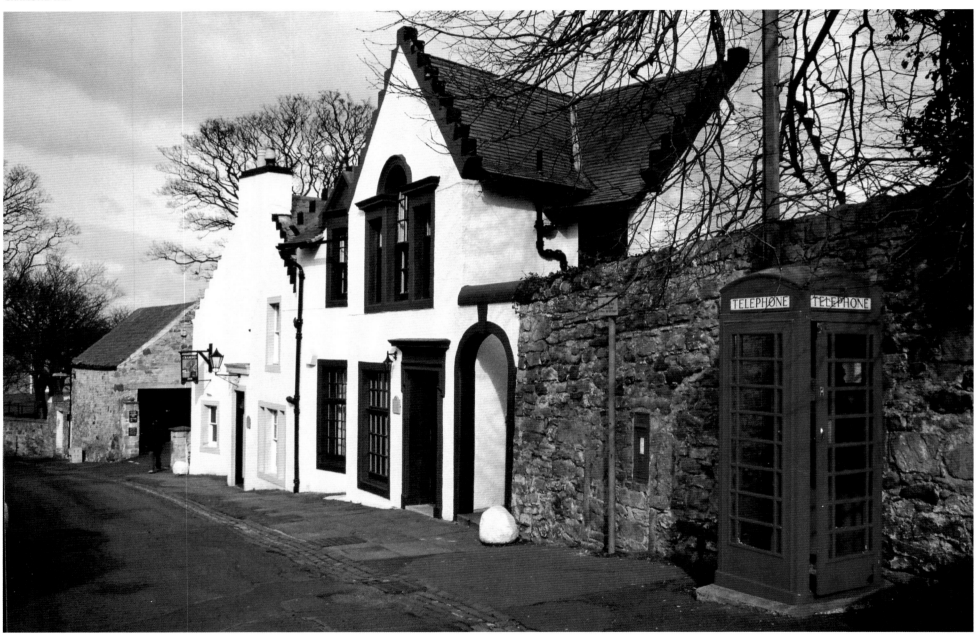

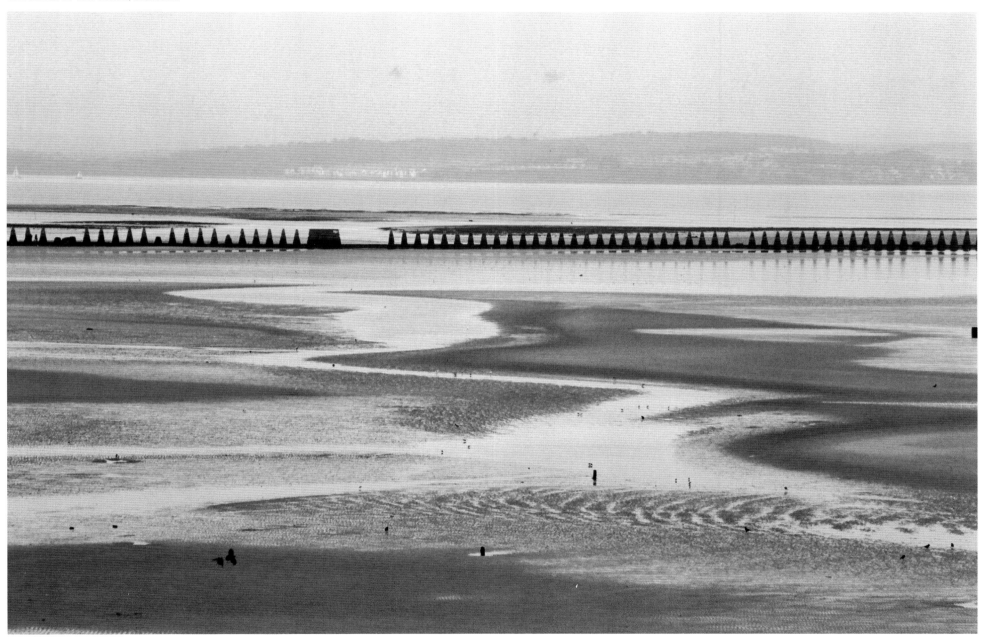

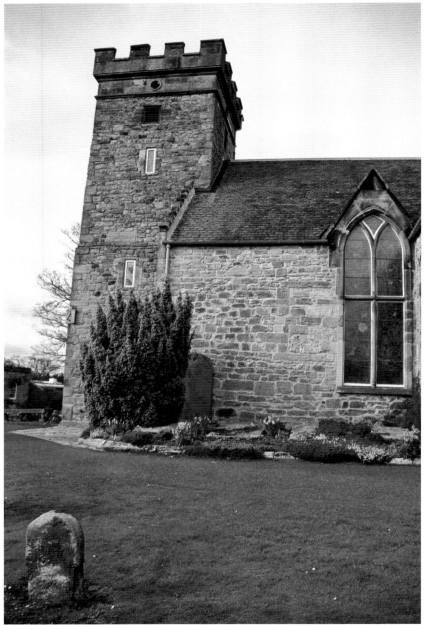

only remnant is the Bruntsfield Links. It is still common land and even though it is home to an ancient golf course, the people of Edinburgh have the right to use it.

Scottish kings bestowed other, more generous gifts. Because the Stewarts gradually adopted Holyrood as a royal residence, power and power-seekers gravitated to Edinburgh. At the outset of the 15th century the Scottish Parliament, the Three Estates, was in the habit of being peripatetic, like the royal court, but by 1500 it had more or less settled in the city, convening in the castle and at Holyrood Abbey. When James V decreed in 1532 that the Court of Session and the College of Justice should also sit in Edinburgh, it had become *de facto* the capital place of Scotland.

The continued royal preference for Holyrood meant that the castle had to find other, more everyday functions. A cannon foundry was fired up and barracks built. In 1573 the eastern defences were badly damaged by an English army sent to intimidate Mary Queen of Scots and her supporters. David II had built an elaborate tower between 1368 and 1377 which guarded the main entrance to the castle and looked down over the town below. It also contained private royal apartments. But when English artillery had cast down its walls, they were not replaced. Instead the Half Moon Battery, curved to withstand a barrage better, was raised up on the foundations of David II's tower on the orders of the Regent Morton, and a portcullis gate added.

As Edinburgh Castle diminished as a political focus, power began to attach itself to the burgesses who lived in the growing town down the hill. In 1482 James III had granted them a greater measure of autonomy. A town council had evolved and both merchants and craftsmen formed themselves into associations. But James III's Golden Charter allowed the Edinburgh provost and baillies to dispense justice, acting like county sheriffs. These men grew very influential and the city's government stayed in their hands until the Burgh Reform Act of 1833.

The jurisdiction of the town council was unambiguous. The Flodden Wall of 1513 marked its extent and in the early 16th century it was kept in good repair. From the Netherbow Port at the foot of the High Street it ran south down St Mary's Street (the house frontages themselves had formed part of the original makeshift defences) and from there climbed up the incline of The Pleasance before turning right and west along the ridge of Lauriston Place. It then turned north to meet the bottom of the Castle Rock at the West Port. There three roads met and on the arch of the old gate the heads of traitors were traditionally spiked. The burgesses maintained the Flodden Wall less out of a concern for defence (occasionally it was little more than someone's back garden wall) and more as a means

of defining the city. Municipal income derived mainly from customs paid on goods coming in to Edinburgh's markets, and while the Flodden Wall would not have resisted an army, or even a regiment, it did deter smugglers.

In the 16th century the economy boomed. As the city settled into its role as a capital, commerce followed. Between 1501 and 1597 the revenue collected on goods multiplied from £1,758 to £8,833. And the population rocketed, doubling from 12,500 in 1516 to more than 25,000 a century later. Squeezed in by the Flodden Wall, it was the most densely packed urban population in Europe. The smoke from countless unswept chimneys, concentrated in a small area, gave rise to the nickname Auld Reekie.

In his epic poem, *Marmion*, set at the time of the battle of Flodden, Sir Walter Scott saw the city from afar. The sentiments sound more like the author's that those of Lord Marmion, the fictional hero, when he first catches sight of Edinburgh:

Still on the spot Lord Marmion stay'd,
For fairer scene he'd ne'er surveyed.
When stated with the martial show
That peopled all the plain below,
The wandering eye could o'er it go,
And mark the distant city glow
With gloomy splendour red:
For on the smoke-wreaths, huge and slow,
That round her sable turrets flow,
The morning beams were shed,
And tinged them with a lustre proud,
Like that which streaks a thunder-cloud.
Such dusky grandeur clothed the height,
Where the huge castle holds its state,
And all the steep slope down,
Whose ridgy back heaves to the sky,
Piled deep and massy, close and high,
Mine own romantic town!

Much of the romance of Edinburgh swirled around its history and Scott was the acknowledged master and inventor of the historical novel, often creating fictional characters as actors in real events. His feel for the twists and turns of history which unfolded in its streets was unrivalled.

By the middle of the 16th century what was perhaps the most turbulent and incendiary phase of Edinburgh's long story was about to crackle into life. For decades Europe had been convulsed by the conflicts dividing the church, what became known as the Reformation. By 1560 Scotland had ceased to be a catholic nation, at least in name, and one of the most energetic and famous reforming ministers was John Knox. What may well have

been his house still stands in the High Street and it is a superb example of Edinburgh's late medieval style of architecture. Described as a sermon in stone, there is a sculpture of Moses (also serving as a sundial) on one corner and an inscription, Love God Above All And Your Neighbour As Yourself.

The reforming mob omitted to take this advice seriously as they set upon the properties of the church around Edinburgh. The Franciscan friary on the site of Greyfriars Kirk was burned down in 1558 and the Dominican convent of the Blackfriars was pillaged and destroyed a year later. Perhaps the most regrettable casualty of all that zeal was the church of the White Friars, the Augustinian Canons at Holyrood. But reforming fury was not entirely responsible for its ruination. In the time of the Rough Wooing, when Henry VIII of England was attempting to effect a dynastic marriage by force, his armies burned the beautiful church in 1544 and three years later stripped the lead off its roof. Holyrood Abbey was as near as Edinburgh came to a cathedral, but perhaps for that reason the mob had no love for the old building and in 1570 much of it was pulled down.

Good things also emerged from the Scottish Reformation. The central and revolutionary idea of the priesthood of all believers, that all ordinary Christians ought to be able to read the Bible, the Word of God, for themselves without any need for interpretation took a strong hold in Scotland. Universal literacy was a sacred requirement and it demanded universally available education – and, miraculously for a small and poor country, Scotland achieved something close to this devout ideal within two or three generations of Knox and his fiery sermons.

Edinburgh benefited particularly, and immediately. The oldest school in the city, the Royal High, was probably founded by the canons at Holyrood. After the wreckage of the mid 16th century, it moved to the garden of the ruined Dominican monastery at the foot of Blackfriars Street. Remembered in the street name of the High School Yards, the Royal High flourished on its new site, in its new central role and it was vigorously and famously independent. When a town baillie came to the school to sort out a dispute over holidays, one of the boys shot him dead at the gates.

As a result of the particular nature of the Scottish Reformation, education became a defining and creative force in Edinburgh's development. Known originally and simply as the Town's College, Edinburgh University grew up near the site of the Royal High School. Given a founding charter by James VI in 1583, it is the oldest non-ecclesiastical university in Britain, and was an immediate success. At first making use of the buildings around the ruined Kirk O'Fields it eventually moved

64

LIBERTON VILLAGE

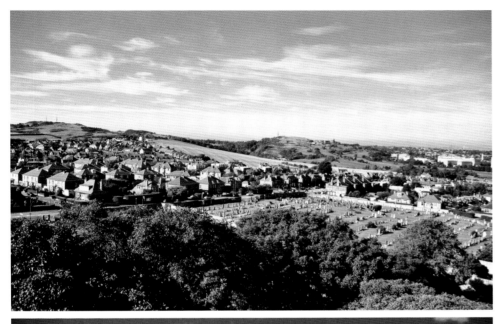

LIBERTON KIRK

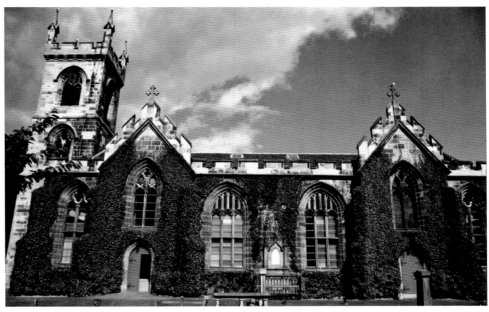

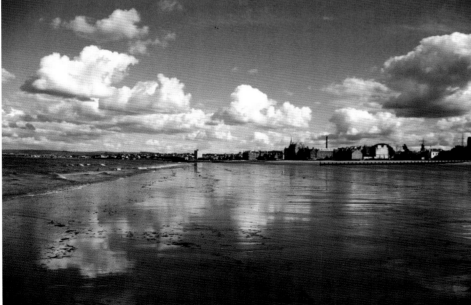

PORTOBELLO BEACH

DUDDINGSTON LOCH

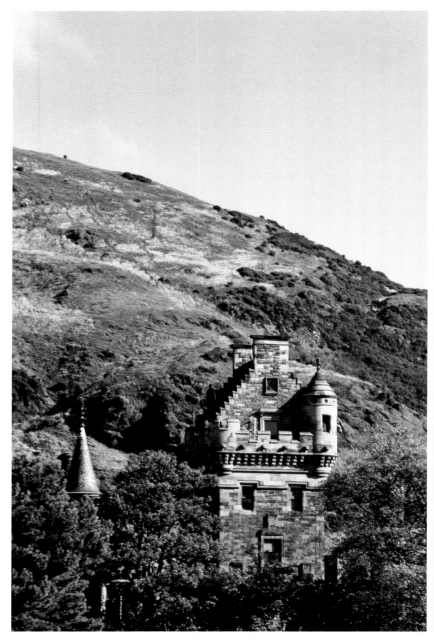

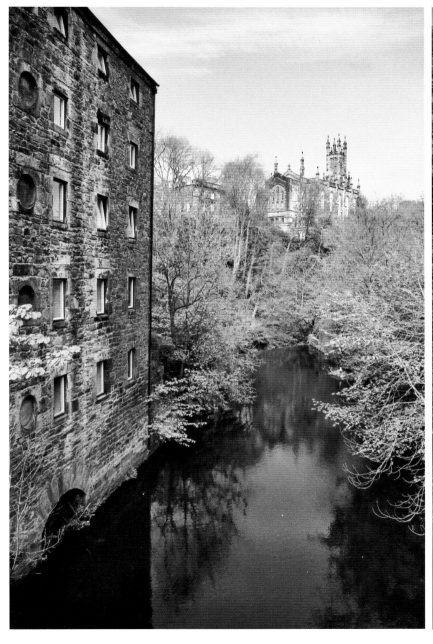

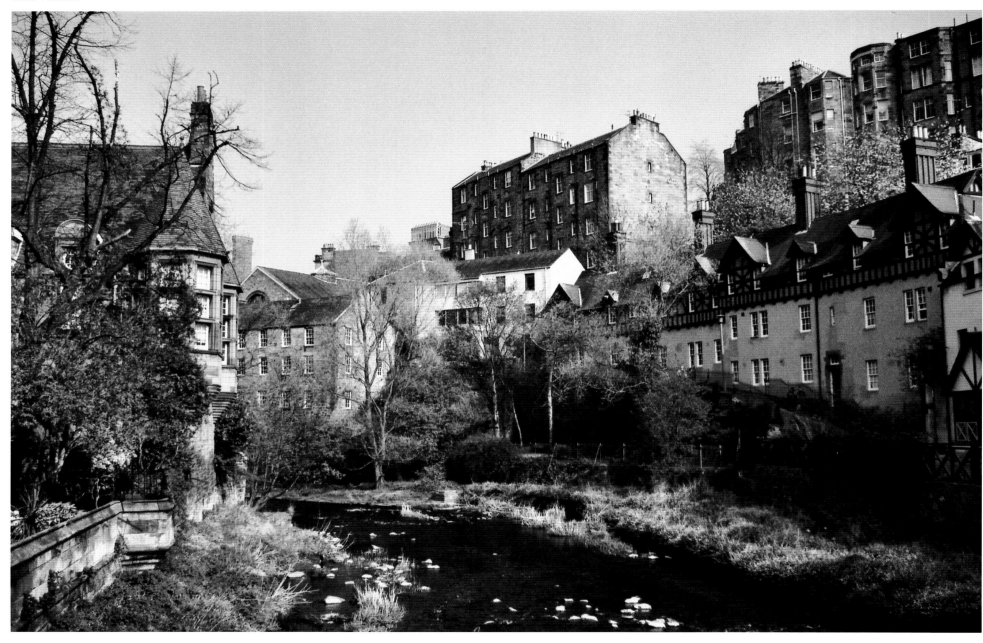

into what is now called Old College in South Bridge. Surely one of the most beautifully proportioned buildings in the city, it was designed by Robert Adam and completed in 1818-34 by William Playfair. On the Old College dome stands the Golden Boy, a gilded youth carrying the torch of learning.

In the early morning of 24th March 1603 Elizabeth I of England died. One of the ladies of her bedchamber, Philadelphia Carey, cut the coronation ring from the queen's puffy and arthritic finger and ran downstairs to the palace courtyard. With his horse saddled, her brother, Robert Carey, was waiting. Wishing to be the first to bring the news to James VI of Scotland, he had organised a series of fresh horses to be posted at intervals on the great north road between London and Edinburgh. Carey hoped for preferment after he had brought the news James had been waiting for all his life.

Having secured the dead queen's ring safely in a pouch, Carey kicked on his horse hard and galloped out of London. It took 60 hours to make the 400 mile journey – and it would have been even faster but for a bad fall somewhere near the Tweed Fords at Norham. Having pressed on, in some pain and badly bruised, through East Lothian, Carey at last clattered into the cobbled courtyard of Holyrood Palace. His cloak and boots caked in mud, cut and bloodied down one side of his face, the messenger from London roared that the king should be woken immediately. Servants scattered, but finally Carey was admitted to the royal bedchamber. He knelt and was the first to acknowledge James VI of Scotland as King of England and Ireland, and as proof that it was so, he gave him the old queen's ring. From that moment on the history of Edinburgh changed.

There was no overlap, no handover period. Even though James was the acknowledged successor, he wasted no time, took power quickly and asserted a new authority. Preparations for the journey to London were put in hand the morning after Robert Carey cantered into the palace courtyard, and by the end of April 1603 Edinburgh no longer played host to a royal court. And as important, the noblemen and their families who lived in the Canongate and in the city were also leaving for the south. Preferment required propinquity and they hoped for continued favour at Westminster, not thinking twice about abandoning Holyrood. In any case there might be rich pickings as the old regime was replaced by the new in a much wealthier and more prosperous country.

Edinburgh turned away to other concerns, and to a growing interest in education. In 1628 a colourful character died. Jinglin Geordie Heriot had made his fortune as a goldsmith and a moneylender and James VI and his queen, Anne of Denmark, had been favoured clients. Jinglin Geordie's huge fortune was to be spent

for *the maintenance, relief, bringing up and education of poor, fatherless bairns, the sons of freemen of Edinburgh*. George Heriot's Hospital, the school which now stands in Lauriston Place, was the result and its opening in 1659 began a long and honourable tradition in Edinburgh.

When the first boys came to Heriot's, they wore a 'sad russet' uniform and black hats. Edinburgh's streets still see thousands of schoolchildren on weekdays in their distinctive uniforms; maroon for George Watson's, scarlet for sixth formers at Stewart's Melville and Mary Erskine's, and blue and grey for Heriot's. The old Royal High School's colours were black and white, perhaps a long echo of the habits worn by the White Friars at Holyrood. To some, the fee-paying schools of Edinburgh smack of privilege, and that is true, but they are also a living testament to a particular devotion to the importance of education. Daniel Stewart, George Watson and the other philanthropists could have left their fortunes to their families or any number of other causes. The traditions they helped found are robustly alive, sustained by former pupils' associations and the likes of their famous rugby clubs. The goal surely ought to be an extension of a similar quality of education to every child in the city.

Edinburgh education is famous across the world for other reasons than antiquity. Miss Jean Brodie embodied a set of paradoxical attitudes when she taught the *crème da la crème* at the Marcia Blaine School. While she always championed the supreme value of education, for girls as well as boys, Miss Brodie was also an admirer of 1930s European fascism and especially fond of Mussolini. The Marcia Blaine School was apparently based on James Gillespie's in Marchmont and the brilliant author of *The Prime of Miss Jean Brodie*, Muriel Spark, was a former pupil.

The second great fictional educational creation also came out of Marchmont and was again based on a real and eccentric school for girls. A motto of Light and Joy and a liberal curriculum were the hallmarks of St Trinnean's and when the artist, Ronald Searle, encountered some of the girls during the Second World War, he drew a picture of genteel chaos. The St Trinian's films became legendary and the portrayal of the headmistress by Alastair Sim was a beautifully observed caricature of certain Edinburgh middle-class attitudes. Having been brought up in the city, he knew them well. Actresses long past school age have been wearing gymslips again as a new St Trinian's film is released.

While masons worked on the building of George Heriot's Hospital in the first half of the 17th century, the Edinburgh town council worried about the loss of the royal court. Money as well as status had leaked out of the city, and anxious that they might lose the Scottish

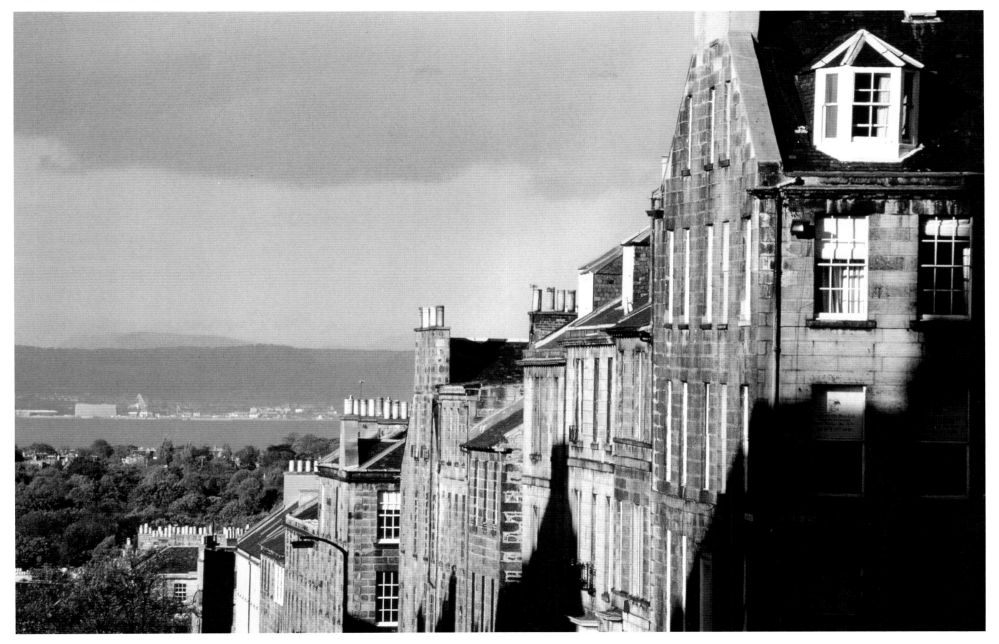

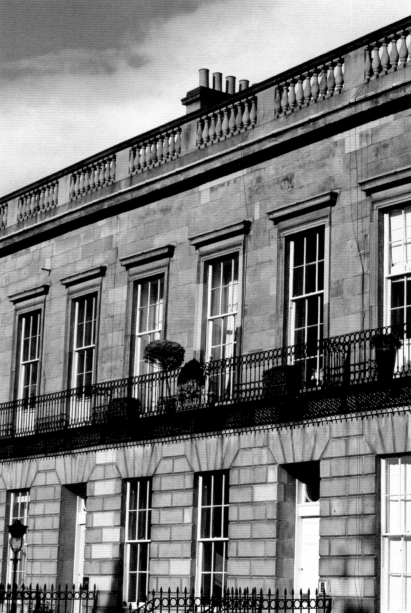

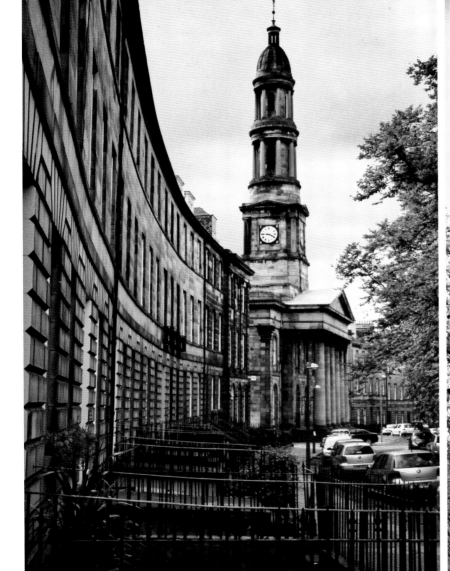

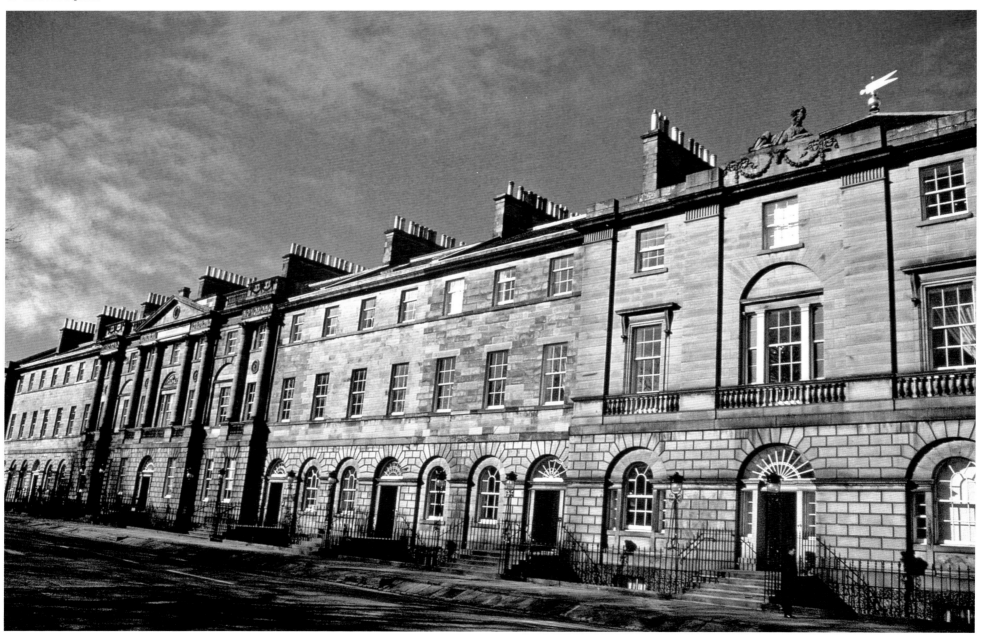

Parliament and the Court of Session as well, they set about providing better accommodation. Both bodies had been forced to use the dingy Old Tolbooth and neither were happy. On the site of the manse of the minister of St Giles, Parliament House was raised, and it contained the stunning Parliament Hall and new courts of justice. The Hall is covered by a remarkable hammerbeam roof and lit by a dazzling stained glass window in the south gable end. Lawyers still pace up and down in this stately space, whispering to their clients before and after appearances in the adjacent courts.

What is mistakenly known as the English Civil War also involved Scotland and Ireland and some of the sparks which ignited the conflict first flew in Edinburgh. When Charles I tried to impose bishops on the presbyterian Church of Scotland (and briefly make St Giles a cathedral), he met outraged opposition. Since the early reforming measures of the 1560s and 70s, Scottish

divines had been developing a radical and extraordinary doctrine. They came to believe that Scotland was a nation specially covenanted to God. In Christ's Kingdom of Scotland, the Principal of Glasgow University, Andrew Melville, had informed Charles' father, James VI, that he was 'not a head, nor a king but merely a member', and in any case 'only God's silly vassal'.

As Charles I blundered on with his attempts to bring Scotland into religious conformity with England, a National Covenant was drawn up, and with great ceremony, signed by many nobles and notables in Greyfriars Kirkyard. In what were known as the Bishops' Wars in 1639-40, the king was defeated and forced to abandon his efforts at coercion. One of the most effective soldiers in the Covenanting army was James Graham, but when the Civil War began in earnest, he changed sides and joined the royalist army at Oxford. In 1644 he was made Marquis of Montrose. For

two years he fought a brilliant campaign in Scotland with a small force of crack troops, mainly Irishmen and Highlanders. But after defeat outside Selkirk, he was forced to flee to the continent. Five years later, he was defeated again at Carbisdale in Sutherland, betrayed and brought as a prisoner to Edinburgh. Condemned as a traitor, Montrose was to suffer an appalling death by disembowelment and hanging. Crowds gathered in the High Street to watch. Here is a contemporary account:

When he came to one of the gates of Edinburgh, he was met by some of the magistrates, to whom he was delivered, and by them presently put into a new cart, purposely made, in which there was a high chair, or bench, upon which he sat, that the people might have a full view of him, being bound with a cord drawn over his breast and shoulders and fastened through holes made in the cart. When he was in this posture the hangman took off his hat … the streets and windows being

full of people to behold the triumph over a person whose name had made them tremble a few years before … In this manner he was carried to the common gaol, where he was received and treated like a common malefactor …

The next day they executed every part and circumstance of that barbarous sentence, with all the inhumanity imaginable … The hangman brought the book that had been published of his truly heroic actions, whilst he had commanded the kingdom, which book was tied in a small cord and that was put about his neck. The marquis smiled at this new instance of their malice … and so renewing some devout ejaculations, he patiently endured the last act of the executioner.

The householders who leaned out their windows to jeer at Montrose may have witnessed a grisly medieval spectacle make its way up the High Street, but they were living in a changing city. In 1621 the town council forbade thatched roofs, insisting on slates or tiles. Too many fires had started when sparks had floated upwards and caught. And after 1674 no new wooden buildings on the street frontage were permitted. Thomas Gledstane's house in the Lawnmarket was built in the 17th century and it still stands in its original condition, now called Gladstone's Land (another name for a tenement). Not only does it have well-made stone frontage, its arcading is also preserved. The town council had decreed that all the High Street shops should have arcades in front, but only one survives.

The burgeoning population of the city had long ago exhausted the woods of the Burgh Muir, and parts of it had been adapted for recreation. As early as 1457 James II was concerned that men were not taking time to practise their archery, a necessary martial skill. He fulminated over their alternative pastimes: 'the football and golf [should be] utterly cried down and not be used'. His descendants were more tolerant and James VI is credited with introducing golf to England, and even worse, he had appointed an Edinburgh bowmaker, William Mayne, to make golf clubs for him. Bruntsfield Links is still a golf course and the shortness of the holes offers a good sense of how the game used originally to be played. Now called pitch-and-putt, it used to be a matter of accuracy rather than the tremendous power needed to tackle holes 500 and more yards long. Golf was also played at Leith Links, probably before it was established at Bruntsfield. Leith was home to the world's oldest club, the Honourable Company of Edinburgh Golfers before they moved first to Musselburgh and then to Muirfield in East Lothian. The Open Championship was, in essence, an Edinburgh creation although St Andrews later played a part in the development of the game.

The 17th century saw the beginnings of another

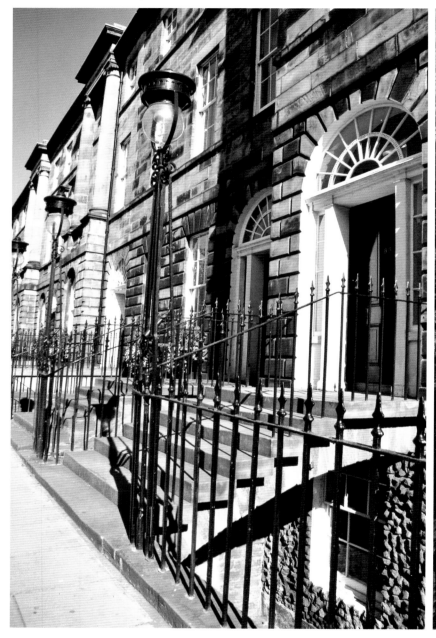

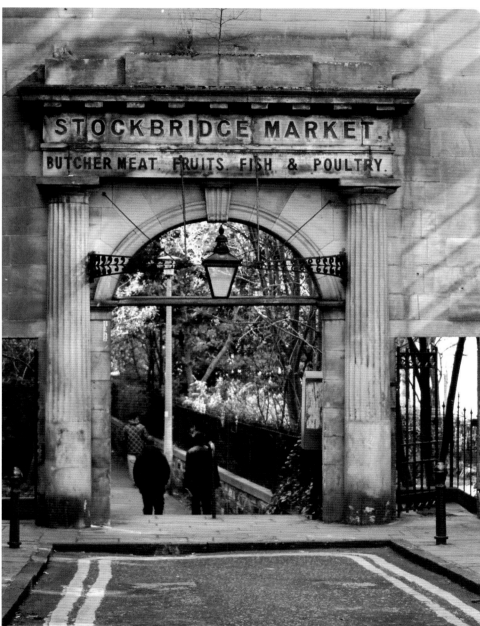

tradition in the city. In 1695 the Bank of Scotland was founded, a year after the Bank of England. It became the first in Europe to print its own notes. The present headquarters dominates the northern flank of the Old Town, built on a platform near the top of The Mound. In the beginning the new bank enjoyed monopoly powers, granted by the Scottish Parliament, but after the catastrophic failure of the Darien Scheme (Scotland's attempt at colonialism in Central America) and the Act of Union with England in 1707, these were removed and in 1727 the Royal Bank of Scotland was brought into being and based in Edinburgh.

The rivalry was more than commercial. The Bank of Scotland lost its monopoly chiefly because it had been involved in raising cash to support the 1715 Jacobite Rebellion. Its political sympathies were Tory and the Whig government of the time needed a counterbalance. The Hanoverian and Whig-supporting Royal Bank of Scotland supplied it and for a generation the two institutions were ferocious rivals in what were known as the Bank Wars.

Historians have argued that it was the financial ruin caused by the failure of the Darien Scheme which forced the Union of the Parliaments in 1707 – that and a series of bad harvests around the turn of the century. Others believe that the Union was the result of sustained politicking by those aristocrats who stood to benefit. One thing is certain, Edinburgh did not like it, and the Edinburgh mob in particular loathed what was proposed.

For a variety of dynastic and foreign policy reasons the English Parliament passed the Alien Act of 1705. This threatened to impoverish Scotland by ending the duty-free trade with England and also, incidentally, removing the automatic right of all Scots to English citizenship (and vice-versa). The Alien Act would come into force unless the Scots accepted the Hanoverian succession and began negotiations on parliamentary union. The Edinburgh mob was incensed, and when an English merchant ship had the ill fortune to seek shelter in Leith harbour, all hell broke loose. The captain, first mate and gunner were dragged off to jail, found guilty of piracy and hanged.

Nevertheless negotiations did eventually begin. Assurances were agreed over the independence of the Church of Scotland and the legal system, and large amounts of money changed hands. 'Bought and sold for English gold' was one later poetic reaction, but there was little evidence of enthusiasm in England for the Union. It was a political necessity, nothing more. When the Scottish Parliament was dissolved in April 1707 and the Union came into effect a month later, Edinburgh wept. Having lost the royal court and now the parliament, it was no longer a capital city. The mob rioted.

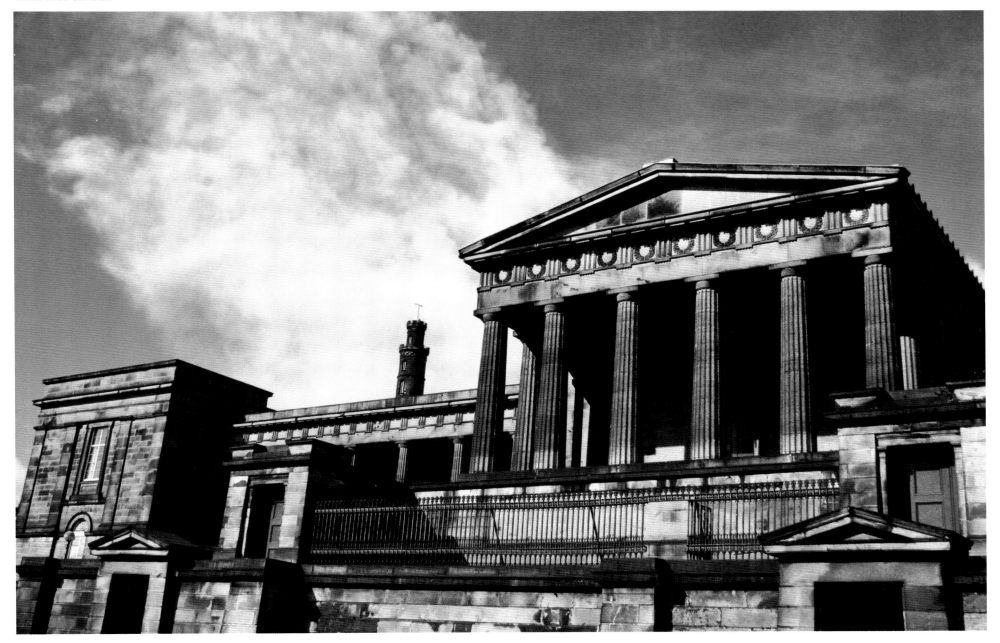

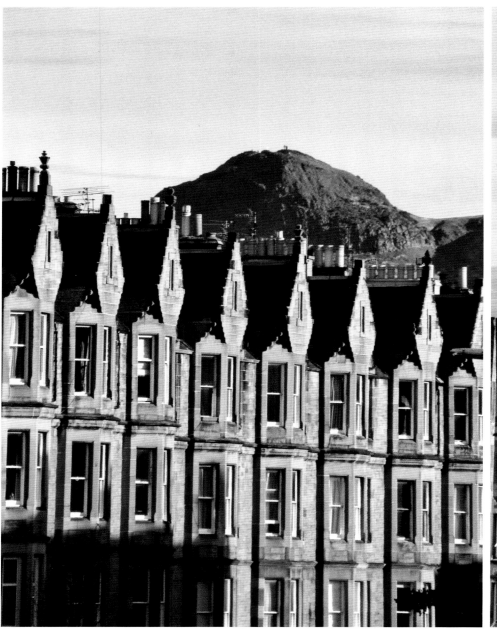

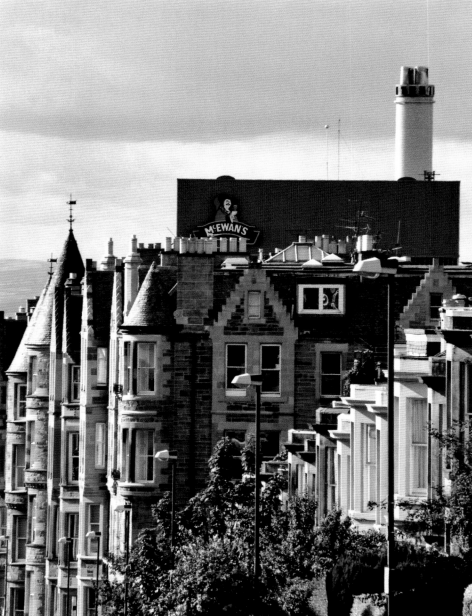

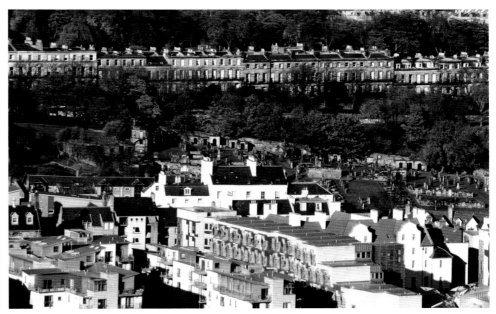

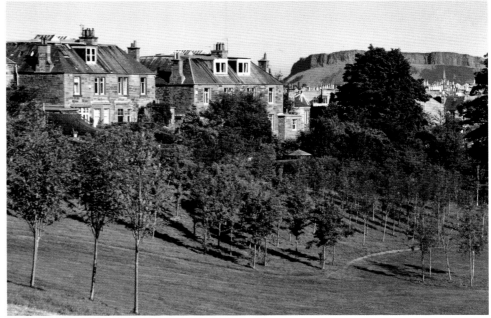

BRAID VALLEY PARK

GREENBANK CRESCENT

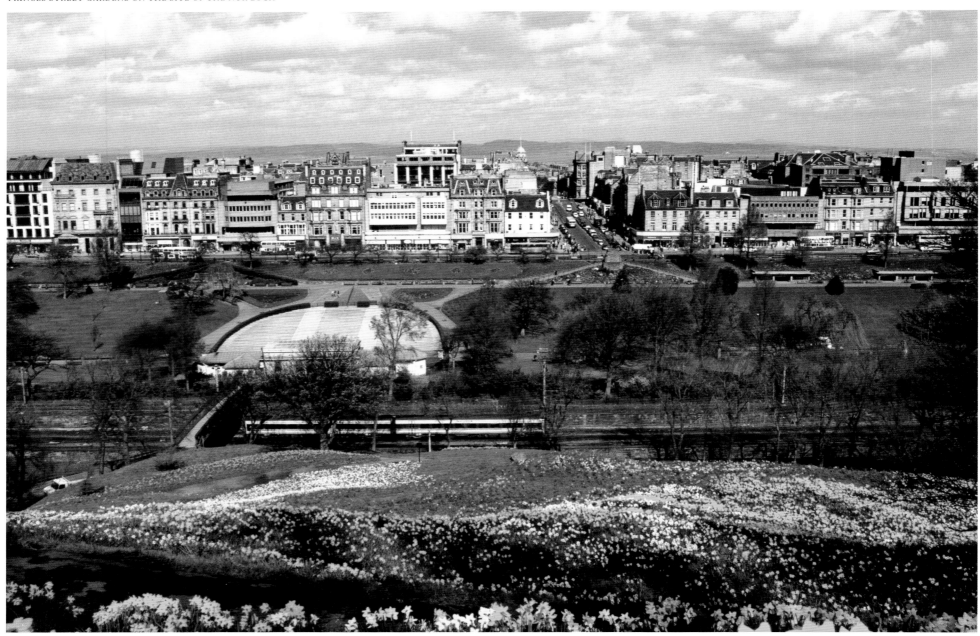

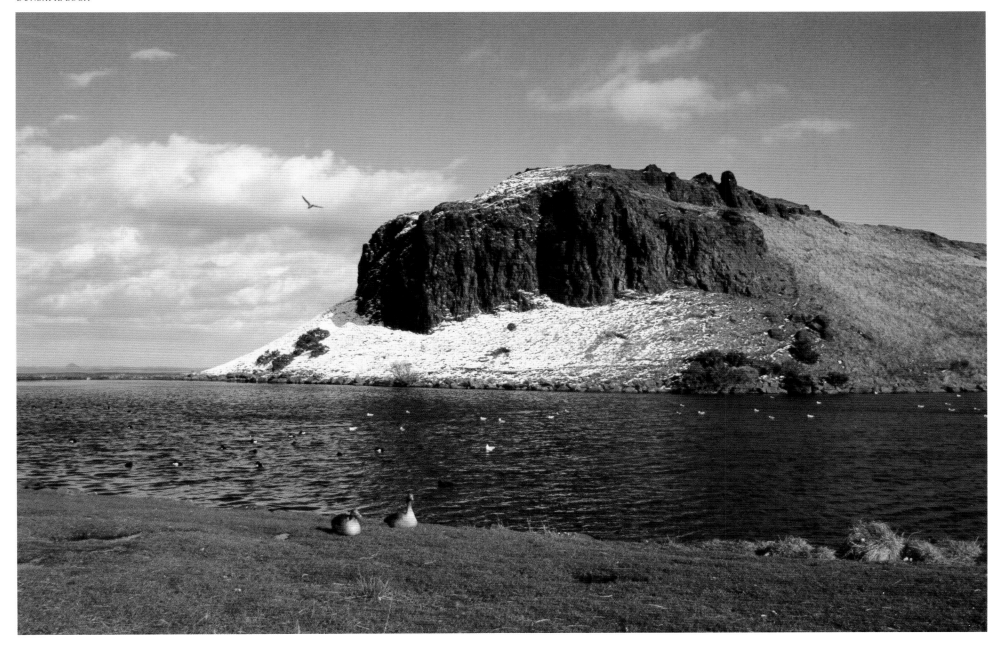

And Robert Burns was retrospectively outraged, writing the angry line above. His poem about the dismal end to the Scottish Parliament is still sung – and to a dirge-like lament:

Fareweel to a' our Scottish fame,
Fareweel our ancient glory;
Fareweel even to the Scottish name,
Sae famed in martial story!
Now Sark rins o'er the Solway Sands,
And Tweed rins to the ocean,
To mark where England's province stands,
Such a parcel of rogues in a nation!

What force or guile could not subdue,
Thro' many warlike ages,
Is wrought now by a coward few,
For hireling traitors' wages.

The English steel we could disdain,
Secure in valour's station;
But English gold has been our bane,
Such a parcel of rogues in a nation!

O would, or I had seen the day
That treason thus could sell us,
My auld grey heid had lien in clay,
Wi' Bruce and loyal Wallace!
But pith and power, till my last hour,
I'll mak this declaration;
We're bought and sold for English gold,
Such a parcel of rogues in a nation!

The Edinburgh mob made it their business to hunt down the parcel of treacherous rogues, and when the English government agent, Daniel Defoe (author of Robinson Crusoe) made the mistake of looking out of the window of his lodgings at Moubray House in the High Street, he was recognised and pelted with stones and rubbish. The writer had only been curious about the source of the disturbance and later sniffed that a Scots rabble is the worst of its kind.

The 18th century Edinburgh mob was very powerful and, drawn from the densely packed streets and closes of the Old Town, it could form in minutes. And the objects of the mob's anger found it difficult to escape. Judges who pronounced an unpopular verdict or a harsh sentence were often peebled, forced to suffer a pelting with pebbles, as they scurried home down a close off the High Street. Perhaps the occasional glance out of the windows of the Court of Session made for more circumspect justice.

A deeply unpopular judgement in 1736 ignited Edinburgh's most notorious bout of public disorder. The prelude was the hanging of Andrew Wilson on the

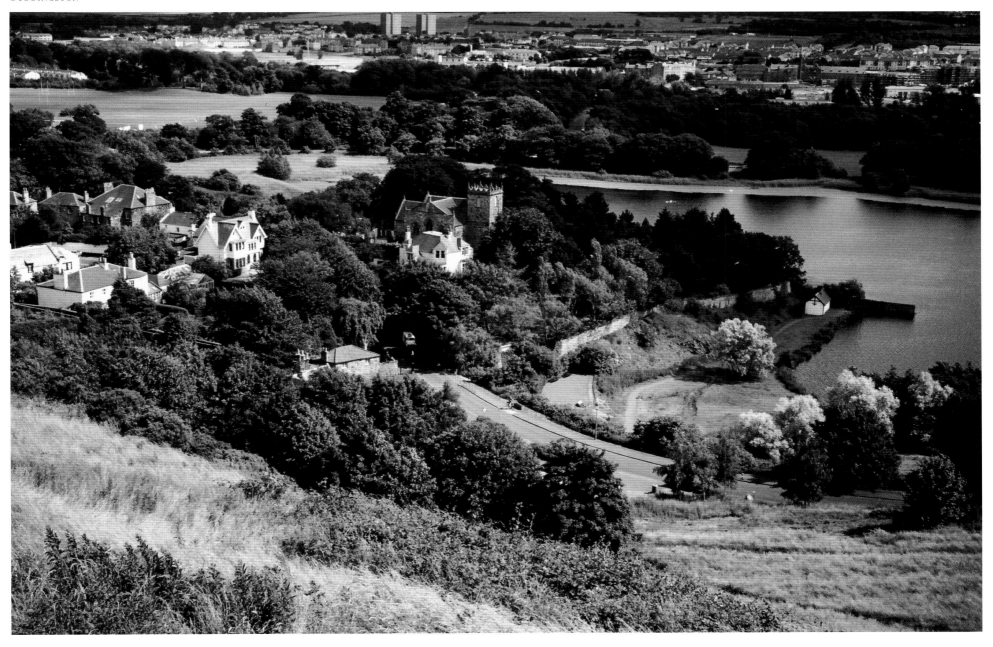

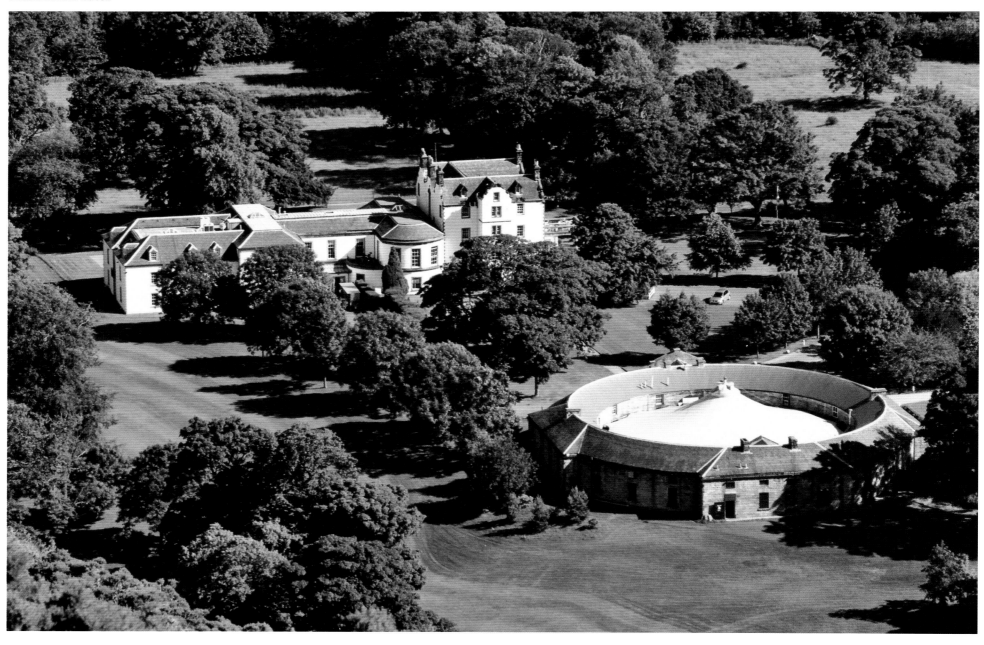

scaffold in the Grassmarket. He was a smuggler but the crime which put a noose round his neck was theft; he had stolen goods from a customs officer. In the Court of Session Wilson argued that he had in fact been the victim and was only repossessing what was lawfully his. The customs officer had victimised him, repeatedly seizing his goods and ultimately rendering Wilson penniless. He had been forced to steal, he claimed. The judges did not believe him and handed down a death sentence. But the Edinburgh mob did, and after the execution, there was an outraged riot.

The Town Guard was summoned, and under the command of Captain John Porteous, they greatly inflamed an already incendiary situation by firing on the crowd. Thirty were wounded or killed. The Town Council was forced to act, Porteous was quickly arrested and in his turn condemned to hang. Sir Walter Scott described the scene in the Grassmarket;

The place of execution was crowded almost to suffocation… and resembled a huge, dark lake or sea of human heads, in the centre of which arose the fatal tree, tall, black and ominous, from which dangled the deadly halter.

But the condemned man did not appear. No guards brought him down to the Grassmarket and rumours began to ricochet around the city. In fact Porteous had petitioned Queen Charlotte (Regent in place of her temporarily mad husband, George III) and a stay of execution had been granted, arriving in Edinburgh just in time. Trembling town magistrates announced this to the crowd – and they in turn immediately took matters into their own hands. After the doors of the Tolbooth had been burned down, Porteous was dragged out and down to the Grassmarket where he was strung up on a dyer's pole.

The tottering tenements of the Old Town could

easily enclose a boiling cauldron of disorder and the Town Council had long been anxious to break out and expand Edinburgh. In 1716 they bought the land to the north, the fields beyond the Nor Loch known as Bearford's Parks. And to the south, the Burgh Loch was at last drained by a farmer and landowner who lived in a grand townhouse at the east end. Thomas Hope of Rankeillour (commemorated in Hope Park Terrace and Rankeillour Street) was given the lease of the boggy area of the loch and he laid out footpaths drained by ditches on either side with lime trees planted along their length. The old loch drained to the west, into the Dalry Burn appropriately at what is now Lochrin Place and then ran into the Water of Leith at Roseburn. Its course has long since disappeared under the city.

As the 18th century wore on the Town Council realised that Edinburgh had to begin to expand beyond the Flodden Wall. Continuing upwards growth was

neither feasible nor safe. After the devastating fire of 1676, Robertson's Land had been built, rising to a dizzying fourteen storeys between the Cowgate and Parliament Square. It was completed in 1684 but only stood for sixteen years until fire ripped through the rookeries of the Old Town once more. Other buildings sometimes suffered partial collapse, losing a gable end, roofs caving in, and the city seemed almost organic – like an ant heap. A map of 1724 shows an astonishing 337 closes and pends leading off the spinal streets of the Lawnmarket, the High Street and the Canongate. By 1984 there were only 110 and 18 of those were closed to public access.

Pressure for expansion was building, and not only for more living space. Judges and town councillors cannot have been comfortable with the power of the Edinburgh mob. When the Porteous Riot brought censure from London, it was the Town Council who were forced to pay a fine of £2,000 (which went to the captain's widow) and not the mob. In the mid 18th century it became more organised, led by the charismatic General Joe Smith, and his lieutenants could summon a crowd of several thousand in only a few minutes. They attacked rack-renting landlords and dishonest merchants, but could also confidently face down the Town Guard.

The legal and mercantile classes of Old Town Edinburgh had long lived a dense, intense version of urban life, full of stark contrasts. While they dined in elegant rooms in the vast tenements, people far down the social scale could live in tiny, filthy hovels reached by the same stair. In Old Assembly Close, only a few yards from the dank cells of Tolbooth prison and the whorehouses and drinking dens of the Cowgate, a strange, repressed form of social intercourse took place. The dancing assemblies, as they were known, were sterile, starchy affairs. The sexes were permitted to dance, very formally, in sets but only under the stern gaze of Miss Nicky Murray, the Lady Directress of the 1750s – and they were certainly not allowed to mix. Men on one side, young ladies on the other. Oliver Goldsmith, the novelist, observed that there was no more intercourse between the sexes than between two countries at war. Only one set was allowed on the dance floor at any one time, and in this ritual-like atmosphere few were able to dance more than once. At one end of the Assembly Room, Miss Murray sat on a high chair raised on a dais, no doubt vigilant for any impropriety.

Meanwhile, outside in the High Street, it was not unusual, according to the Edinburgh chronicler, Robert Chambers, to see some very different sights:

Nothing was so common in the morning as to meet men of high rank and dignity reeling home from a close in the High Street where they had spent the night in drinking.

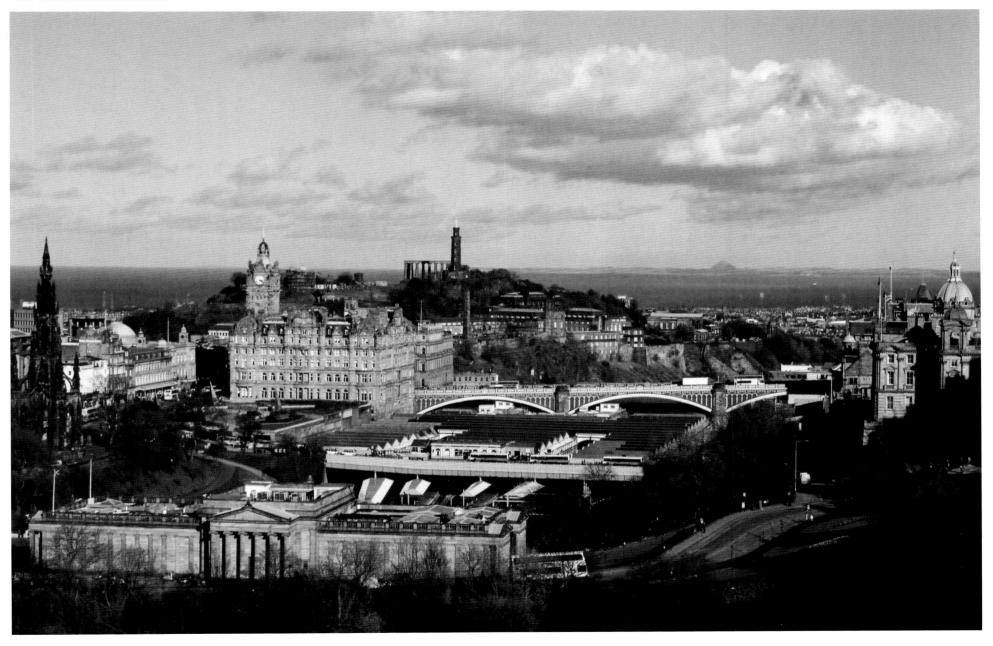

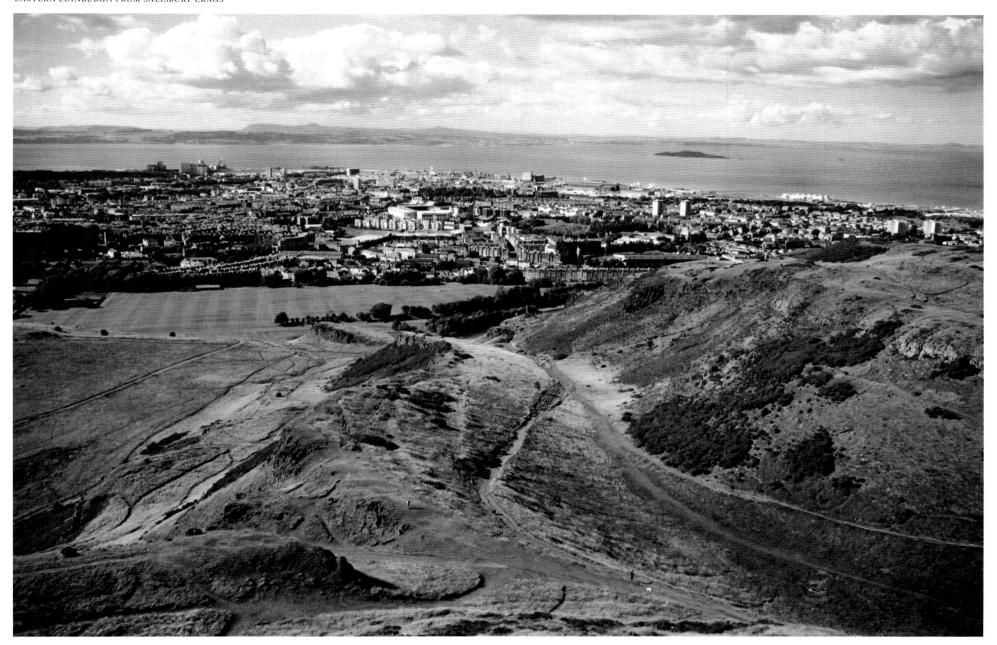

Drunks who could afford it were sometimes escorted through the streets and closes by caddies. Not only could they interpret the vague directions waved at by a wealthy inebriate, they could also fend off any who wished to relieve their charge of his cash and valuables. These men and boys were themselves described as a ragged, half-blackguard-looking set but they had a sound reputation for honesty and dependability. Holding up a storm lantern, the caddies not only led drunks back up their closes and stairs to their front doors and what was surely waiting behind them, they also acted as messengers and bearers. Caddies appear to have acted as an informal but effective police force and an 18th century English observer believed that they were the reason why there were fewer robberies and less housebreaking in Edinburgh than anywhere else. The impression is of native guides in an urban jungle.

Indoors similarly primitive social practices might have raised a modern eyebrow. Even in the grand flats of the Old Town the sanitary arrangements were often somewhat sketchy. In the hoary old cliché sewage and dirty water had probably not been tipped into the street out of upper floor windows (with the cry gardyloo, meaning Watch out below!) since the Middle Ages, but 18th century plumbing had not quite taken over. Under the sideboard in many dining rooms sat a chamber pot and one of the persuasive reasons why the ladies were in the habit of withdrawing to the withdrawing room was to allow the gentlemen to use it – without a break in the conversation. Details such as this act as a surprising gloss on the candle-lit elegance of 18th century Edinburgh society.

In common with most of urban Scotland, such as it was in 1745, Edinburgh stayed loyal to the Hanoverian cause when Bonnie Prince Charlie raised the Highland clans in support of the Stewart claim on the throne. But at the approach of the rebel army, the defenders of the city proved hilariously useless. When flanking Jacobite cavalry encountered a force of government dragoons at Coltbridge, near Roseburn, there was a rout. In what was called The Canter of Coltbrig, the soldiers simply fled for their lives. A Jacobite commander, Lord Elcho, recorded what happened next:

At 8 o'clock at night the Prince sent a message to the magistrates of Edinburgh to demand the keys of the town and to tell them he intended to enter it either that night or the next day, and if there was any resistance made, whoever was found in arms should be severely treated; and besides, he could not answer but if the town was taken by storm his soldiers would plunder it. At ten at night there came four of the town council out to the Prince's quarters to beg he would give them time to think on his demand. This was a message contrived to gain time, for they expected General Cope's army every hour to land

at Leith from Aberdeen, and in case he landed time enough, they intended to wait the event of a battle. The Prince, after they had kissed his hand, told them that he was going to send a detachment to attack the town and let them defend it at their peril; that if they did the consequences would be bad, and if they did not he intended no harm to the old metropolis of his kingdom. As soon as they received this answer the Prince ordered Young Locheil with 800 men to march and attack the town. There came out sometime after another deputation of six councillors; Provost Coutts was one of them. They got the same answer as the first, and the Prince did not see them. The coach that they came out in went in at the West Port and set down the company, and as they were letting out the coach at the Netherbow, Locheil's party who were arrived there rushed in, seized all the guards of the town, who made no resistance, and made themselves masters of Edinburgh without firing a shot.

When the smoke cleared after Culloden, and the Prince had long since fled, Edinburgh began to look to its future. Lord Provost George Drummond put a proposal to the Convention of Royal Burghs in 1752 for Carrying out Certain Public Works in the city of Edinburgh and which contained the rallying cry, 'Let us boldly enlarge Edinburgh to the utmost'. At last.

Some urgency was injected into this stately process when the side wall of a high Old Town tenement suddenly collapsed. Rooms on all six storeys were exposed and the building had to be pulled down. Other rickety structures were examined, and to forestall another disaster, they too were demolished. Radical change was in the air, it was time to move forward.

Lord Provost Drummond announced a competition to find the best layout for a New Town to be built on the other side of the Nor Loch, on the land known as Bearford's Parks (also as Barefoot's Parks in some accounts). By 1767 a winner had been chosen; the 23 year-old James Craig, and his simple three-street grid connecting two squares at either end was adopted. It used the ridge which ran from east to west across Bearford's Parks and the gentle inclines on the northern and southern flanks. Work began immediately and the foundations for the first houses were dug at what is now Thistle Court in Thistle Street, just off St Andrew Square.

Craig's plan resembled a political diagram. The street names were a self-conscious affirmation of the Hanoverian succession and the Act of Union as well as a rejection of the Stewart dynasty and the recent rebellion of 1745/46. George Street was named for George III and was of course the principal, axial street intended to run along the parks' ridge. It was to connect St Andrew Square with St George's Square – but an immediate difficulty arose. In what was, by a whisker, Edinburgh's first new development to follow Provost

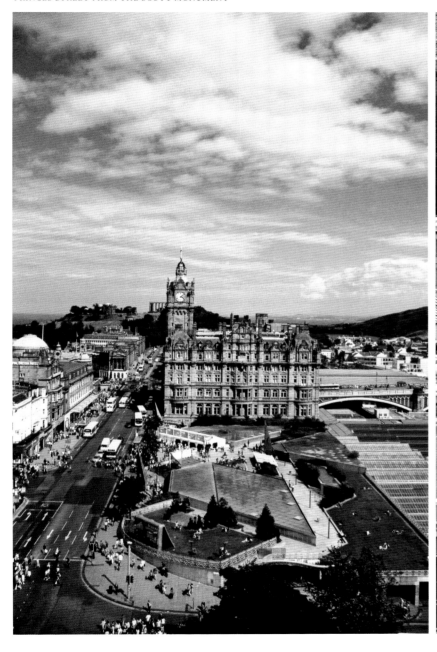

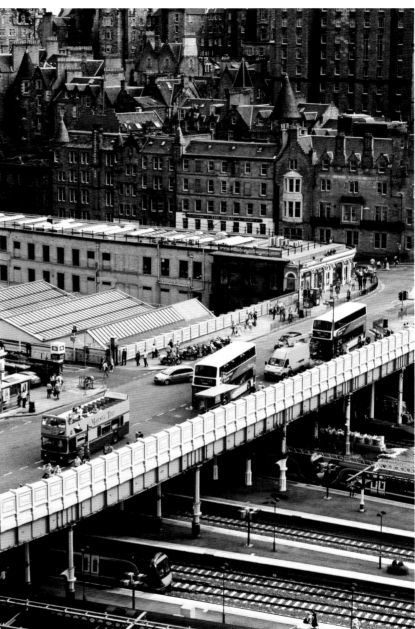

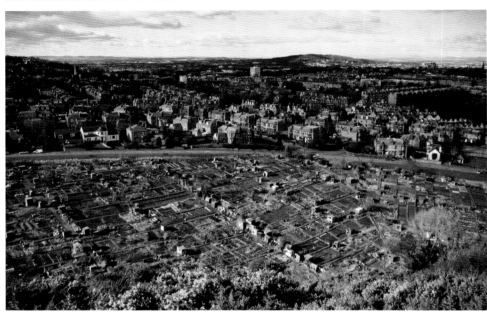

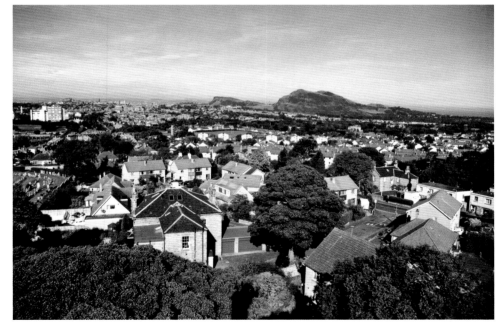

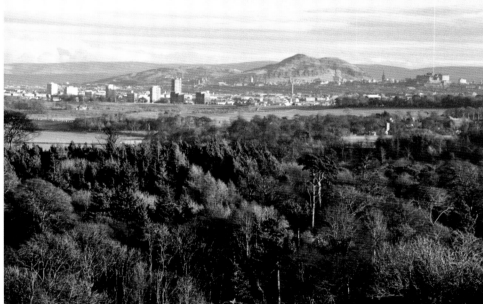

VIEW FROM THE TOP OF LIBERTON KIRK

WESTERN EDINBURGH FROM DALMENY

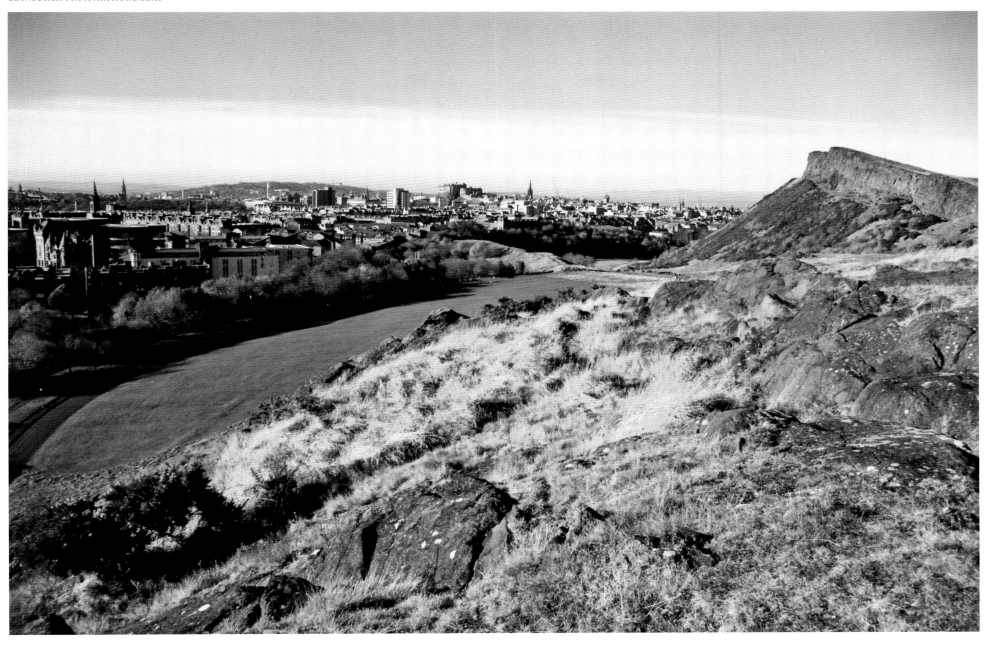

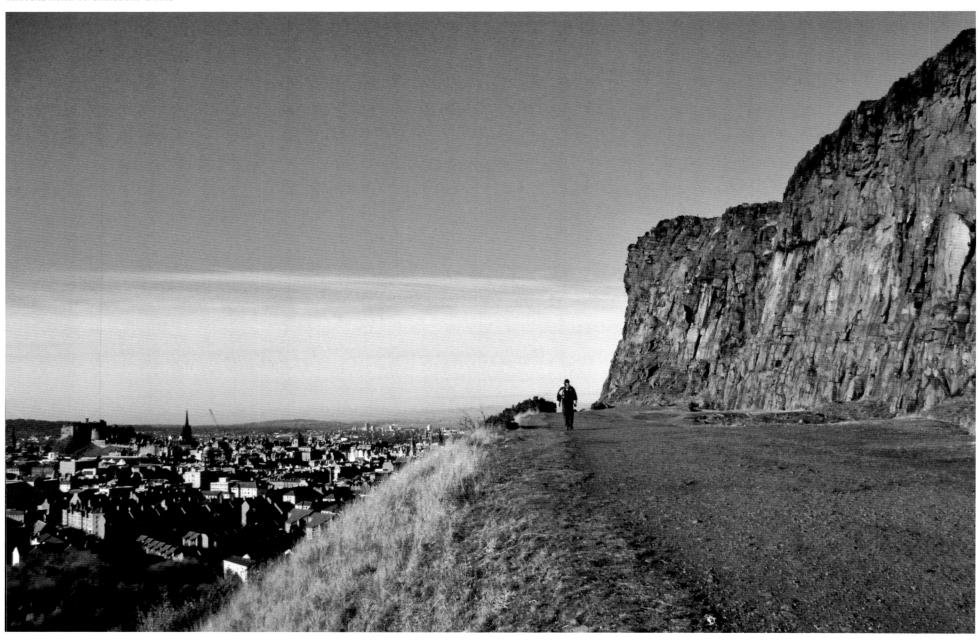

Drummond's declaration, George Square has been laid out on the south side of the city in 1766. It was not named after the saint or the mad king but the architect's brother. As a compromise was reached, Queen Charlotte (almost the saviour of Captain Porteous) was thought to be much pleased to have the western square of the New Town re-named after her.

On either side of George Street, symbolising the Act of Union, lay Rose Street and Thistle Street. To the north was Queen Street and to the south James Craig had marked the track known as the Lang Dykes as St Giles Street. But the king would have none of it and insisted that St Giles Street be changed and named for his sons, the Duke of York and the Duke of Rothesay. Princes Street was the result and the first house was built at the east end in 1769.

Edinburgh's New Town was the largest example of urban planning in 18th century Britain. Intended as a residential suburb, much of the central area has been adapted for retail and business use, but 75% of the whole, expanded New Town is still stubbornly used for housing. Princes Street had shops from the outset, and when building reached the west end in 1805, many of the new buildings had been designed as shops. There was an early attempt to have buildings on both sides of Princes Street, but a group of influential Edinburgh residents argued down the plan. An early outing for what would become a powerful middle-class conservationist lobby.

Craig's layout did not quite work, especially at its east and west ends. Designed as a direct link between the Old Town and the New, North Bridge began building in 1765. It should have connected with St Andrew Square, which in turn should have been built a little further to the east. But Edinburgh town council had not been able to acquire the land just below Calton Hill. The circumstances of ownership were not clear, but it looks as though Sir Laurence Dundas had acquired land in that location and before Craig's plan was published he had decided on a grand house. Until recently it was the Head Office of the Royal Bank of Scotland. More complications were on the way. Dundas then acquired the plot of land immediately to the west of his new house, along the street-line of St Andrew Square, as Craig had laid it out. It became the entrance to the house and its front garden. Either side two identical and beautifully proportioned flanking buildings give the impression of a country house with wings around a central forecourt in front of what is the only free-standing mansion in the New Town. Together the scheme achieves an overall impression of considerable style. But for the Town Council it was a considerable headache. Dundas' single-mindedness seriously upset the symmetry of Craig's plan. To finish the eastern vista along George Street, he had intended to place St Andrew's Church in St Andrew Square.

Another much less satisfactory site had to be found on the line of George Street.

Halfway along Princes Street the Mound was slowly rising. After the Nor Loch had been drained, the Town Council ordered that all the earth dug out of the founds of the New Town's terraces ought to be piled up to create a landbridge linking the bottom of the Lawnmarket with the new development. But once again there were problems. The roads did not quite connect, there being an awkward wiggle between the foot of the Mound and Hanover Street.

Further west Craig's rectilinear layout had to incorporate another snag. The line of the old road to South Queensferry (now Queensferry Street) ran north-west, at an angle from the Lang Dykes. When Hope Street attempted to link Charlotte Square with Princes Street, an unfortunate hairpin turn had to be allowed for as well as the junction with the foot of

Lothian Road. It was a mess only recently sorted out by continuing the Princes Street pavement to Shandwick Place and separating the two competing traffic flows.

Once building work had begun at Thistle Court in 1767, the Town Council hoped that plots would be quickly snapped up. But the New Town took time to become fashionable and while James Craig's layout was to be strictly adhered to (by everyone except Sir Laurence Dundas), the regulations for housebuilding were at first not so rigorous. It may be that the Town Council felt that too many restrictions might discourage buyers. All they insisted on were three-storey terraced houses with sunk basements, usually accessible from the area, a small lower ground floor forecourt. Early variations in design are clear on the north side of St Andrew Square where some houses are faced with smooth ashlar, others with rubble-cut stone while the windows are either architraved or plain.

By the time gangs of masons and their labourers reached Charlotte Square, demand had grown and the New Town had become a much sought-after address. And a masterpiece was created. Designed by Robert Adam in 1791, Charlotte Square was to have no variations in the terraced houses – instead the north and south sides were to mirror each other precisely with severe but impressive and unifying classical temple facades. Nothing as monumental had yet been built in the New Town. Adam's central notion was to plan coherent facades on the theme of a Roman temple but to have eleven three-storey houses behind each one. This time no wealthy developer was allowed to bully his way in and to finish the western vista along George Street and to occupy much of the western side of the square, St George's Church was built. The result is perhaps the most beautiful Georgian square in Britain. And it has been carefully preserved in every detail; the

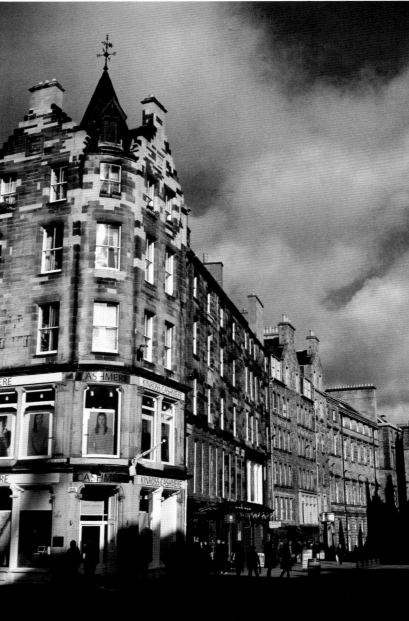

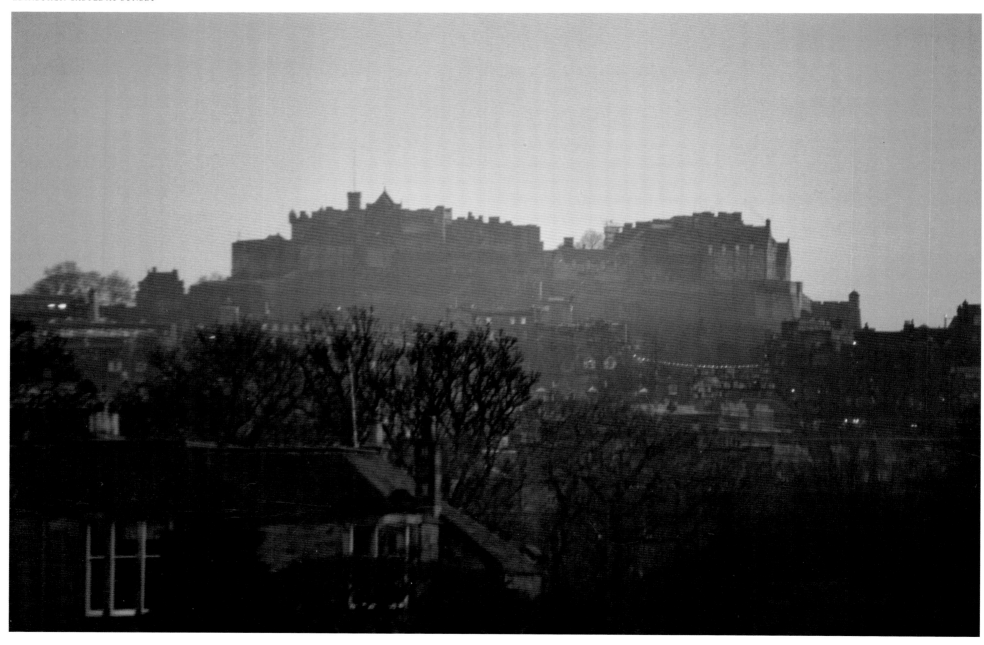

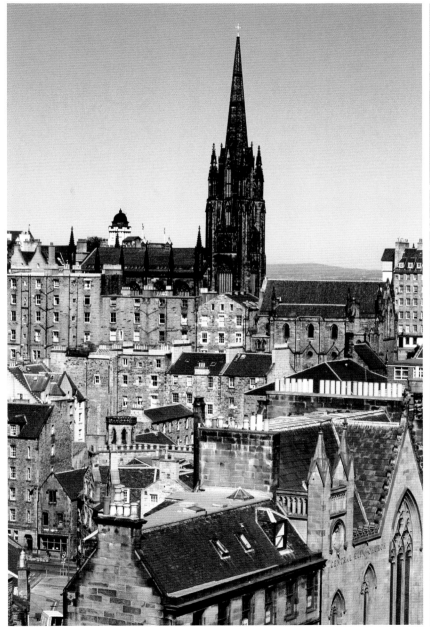

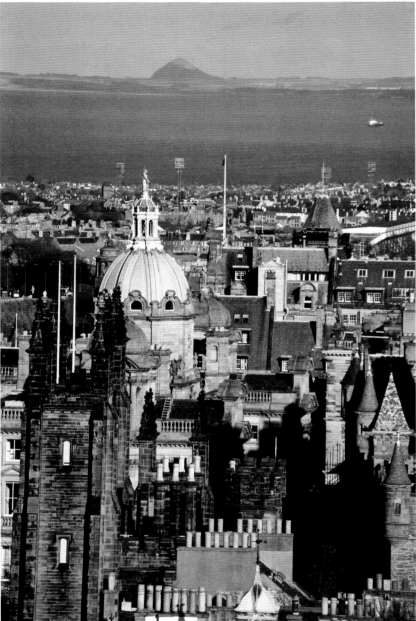

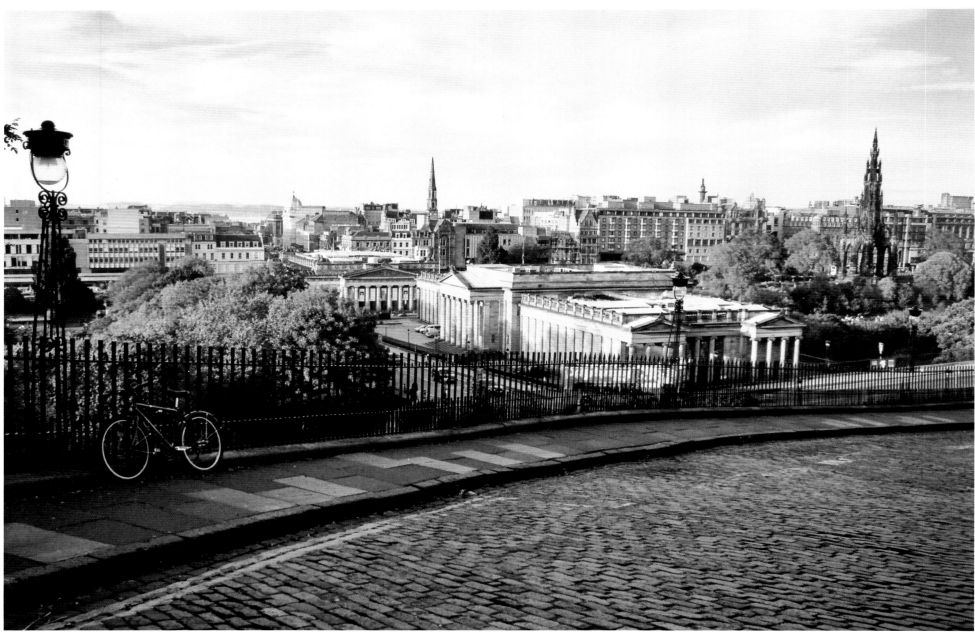

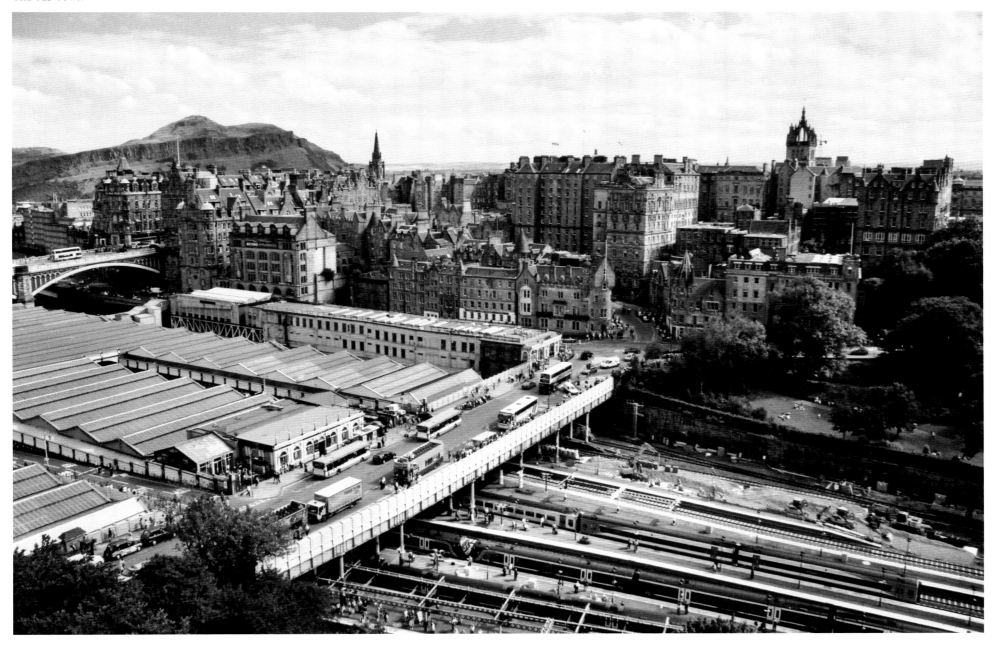

mysterious rectangular stone blocks on the edge of the pavements were a classical version of what Scots-speaking horsemen still call a *loupin on stane*.

In 1760 more than 70,000 people crammed into the tenements of the Old Town and the temptation for the genteel (who generally lived on the upper floors) was to seek to live in 'houses to themselves' in the New Town. As building work gathered pace and Craig's plan took shape, the wealthier citizens began to migrate in numbers across the Nor Loch to live in spacious terraced houses with their own front door and without the need to hold their noses as they passed undesirables on the tenement stair. In fact The Great Flitting became an entertainment for the undesirables, and as the quality packed their furniture, crockery and carpets onto carts, they came out to see them off as they clattered off down the Mound to another life.

Most cities are composed of connected villages, more or less salubrious neighbourhoods, and the Flitting saw Edinburgh begin to divide along these lines. The rickety medieval ant-heap not only lost its wealthier citizens but also a real sense of community. The fact of poor people living on the same stair as the rich and powerful, of people seeing close-up how other, very different lives were lived, of simply talking to each other regularly – all of this appears very attractive now, in an alienated, fragmented urban world.

As the carts rattled away over the cobbles, those who were left in the Old Town enjoyed some dividends. The memory and novelty of these were still fresh in the 19th century when an old lady recounted the pleasures of high living in a house in Carruber's Close, off the High Street, which had been vacated by Lord Elphinstone:

Talk about chimney-pieces – it was the nicest, sweetest thing you ever saw: lovely bunches of grapes, all carved like real, and fruit in baskets and flowers all growing about. Oh my, it was a bonny place to be in! … I used to buy beeswax for the mantel and always spend a good two hours on it on Saturday doing it up. It was bonny – bonny to be in a house like that.

Airs and graces began to float over the rooftops of the New Town as the new residents moved in. Instead of hard-drinking nights in the howffs of the Old Town and early morning staggers up the High Street on the arm of a caddie, the refined pleasures of dancing assemblies were introduced to George Street. On the occasion of the Caledonian Hunt Ball in January 1787, the Assembly Rooms opened. The grand ballroom was lit by 'crystal lustres' and down its impressive length the strictly segregated sexes joined in setts and reels. There was to be no admission without a ticket on any account whatever. As they trudged along George Street, clutching their tickets, some of the new New Town residents may have

cast a longing glance up to the canyons of the Old Town and their warm and friendly howffs down the closes and pends. In more senses than the architectural, Edinburgh would never be the same again.

In 1769 David Hume moved to a house in St David Street, off St Andrew Square. Having been Librarian of the Advocates Library, secretary to several diplomats and a failed academic, one of his principal claims to popular fame in 18th century Edinburgh was his atheism. After a serious drinking session in the Old Town, the somewhat overweight Hume is said to have fallen into an undrained part of the Nor Loch as he weaved his way back to his new home. Unable to extricate himself without help, he appealed to a passing old lady. Ah! she exclaimed, it's Hume the atheist, and refused to pull him out of the bog until he had recited the Creed and the Lord's Prayer. Which of course he did.

David Hume is famous for other reasons. As one of the central figures of the Scottish Enlightenment, the extraordinary outpouring of scholarship, publishing and original thought which came principally from Edinburgh between 1760 and 1800, his reputation as a historian and philosopher is world-wide. Alongside him shone a galaxy of towering intellectual figures who advanced the understanding of many disciplines, from geology to medicine, from horticulture to aesthetics. Hume, William Roberston, Adam Ferguson, Lord Kames and dozens of other men of renown met in a series of clubs in the Old Town; the Poker, the Select and so on. Publications such as *Blackwood's Magazine* and the *Edinburgh Review* carried articles and extracts, but perhaps the most famous literary product of the Scottish Enlightenment was first printed in Anchor Close, off the High Street. The *Encyclopaedia Britannica* became a standard, and world famous.

The particular factors that produced this remarkable intellectual ferment are difficult to describe – but one of the key circumstances which sustained it was the nature of Edinburgh's Old Town. Most of these great figures were near-neighbours and knew each other. They met regularly in the closes and the howffs. Discussion, ferocious argument, competition and cooperation forced the intellectual pace and the production of innovative ideas was astonishing. And much of this was firmly rooted in practicality – and again Edinburgh's intense urban life had a strong influence. The old woman who helped David Hume out of the Nor Loch not only knew who he was, he also knew a great deal about her life.

When he had charge of the Advocate's Library, Hume will have known what a mess Scotland's national archives were in; bundles of uncatalogued papers rotting in the Laigh Hall (under Parliament Hall) and in stores in the Castle. They turned out to be an opportunity for

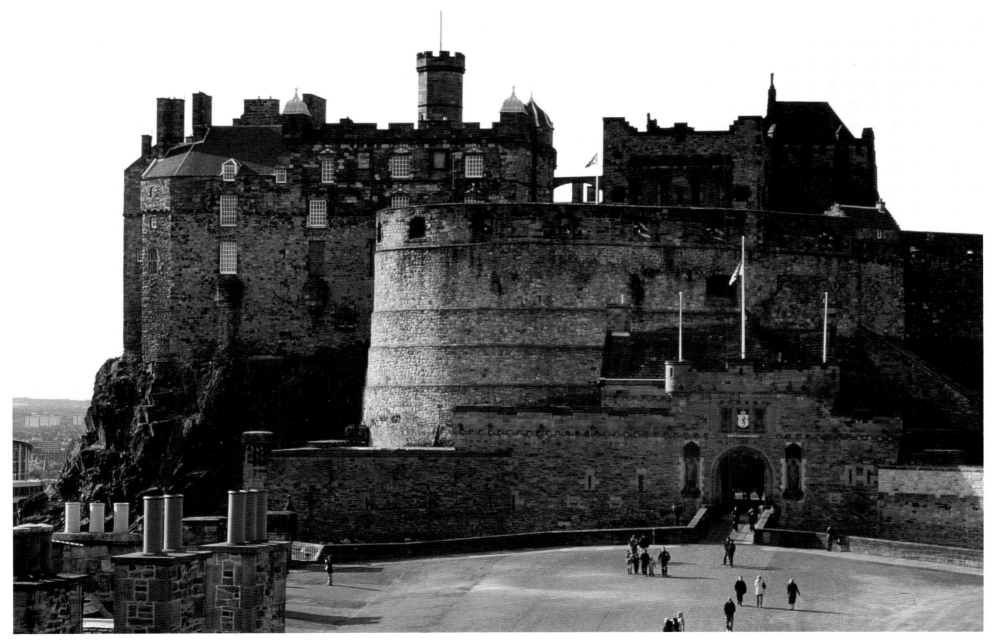

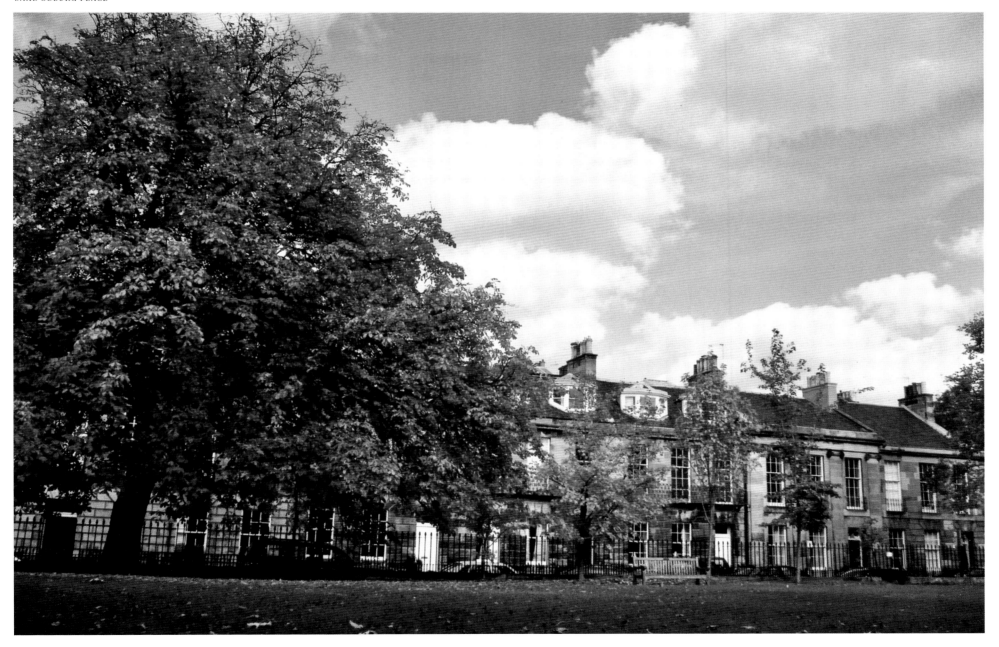

122

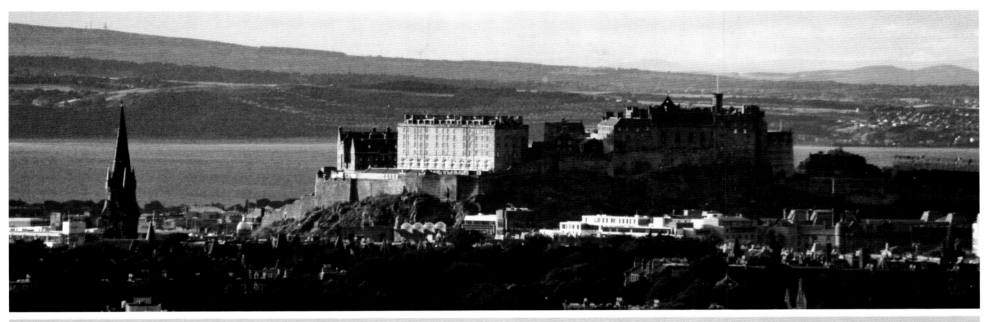

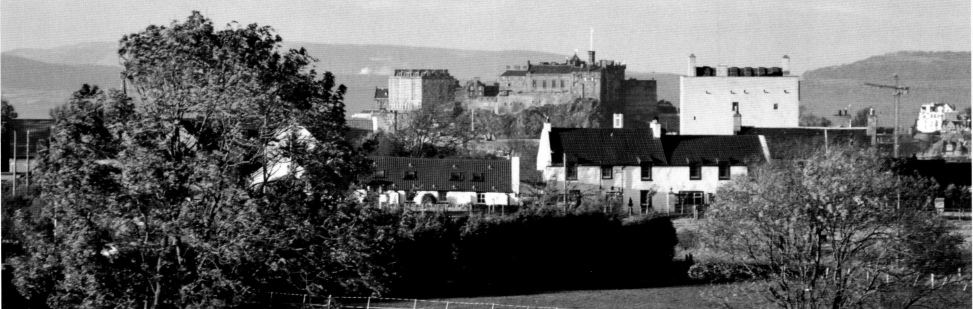

LIBERTON TOWER

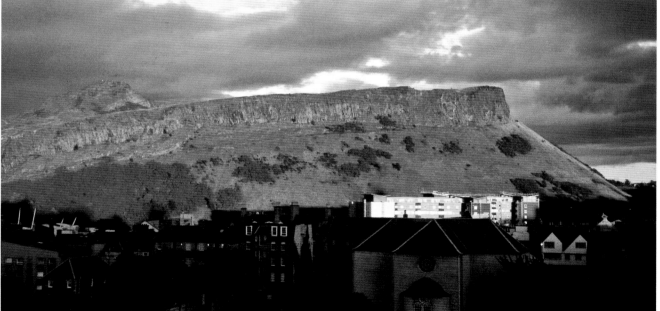

SALISBURY CRAGS

Robert Adam to make another striking contribution to Edinburgh architecture. In 1771 he drew up plans for Register House. It was to be sited at the northern end of North Bridge and paid for by cash from forfeited Jacobite estates. The result is triumphant, the earliest purpose-built archive in Europe, and perhaps the most perfectly proportioned public building in Edinburgh. With New Register House behind, it still functions as the deposit for records of Scotland's births, marriages and deaths.

The memory of Edinburgh is often found in its street-names. The beautiful one-sided terrace to the north of Queen Street Gardens is called Heriot Row because the land on which it and most of the northern New Town was built belonged to George Heriot's Hospital. James Craig's original scheme had eventually proved so popular that demand grew for an extension, and the Heriot's Trust were persuaded to sell the land to the north of Bearford's Parks. It was crossed by Gabriel's Road, an old track leading from Register House down to the Water of Leith, where it loops north towards Inverleith Park.

Very reminiscent of Craig's original, the grid plan has of course completely obliterated the old road and it is laid out in a rectangle of streets stretching from Broughton Street in the east to India Street in the west. Designed for a hillside site by Robert Reid and William Sibbald in 1801-2, the northern New Town is a deftly managed development all built at approximately the same time. Its consequent architectural coherence is very striking. Laid out on either side of broad Great King Street, the scheme connects London Street and Drummond Place with Royal Circus. It was a happy accident that land became available to the north of the first New Town because Craig's plan did not allow for immediate expansion in any other direction. Charlotte and St Andrew Squares had no exits on the western and eastern sides respectively. Only to the north could there be direct connection – from North St Andrew Street to Dublin Street, from Hanover Street to Dundas Street and Frederick Street to Howe Street. The Georgian housing beyond the Nor Loch now dwarfed the area of the Old Town.

When more expansion was planned to the north-west, a brilliant solution was found to get around the awkwardnesses of Craig's layout of Charlotte Square and the diagonal line of the old road to Queensferry behind it. In 1822 the Earl of Moray decided he would cash in on the property boom and sell 13 acres of land between the square and the Water of Leith. James Gillespie Graham proposed Moray Place as the grandest space (the earl was to live at no 28) and made it a polygon linked to Heriot Row by Darnaway Street. To the south west the plots around the oval shape of

Ainslie Place were pegged out, and beyond it Randolph Crescent led to Queensferry Street. It is perhaps the most satisfying example of town planning in all of the New Town, and the grey severity of its general style is much softened by the trees in the gardens of Moray Place, Ainslie Place and Randolph Crescent.

Also in 1822 large crowds made their way down to Leith to see something extraordinary. It had been decided that George IV should pay a state visit to Edinburgh. No reigning monarch had been to Scotland since Charles I in 1633, and it was further decided that the world-famous novelist, Sir Walter Scott, would stage-manage the entire affair. The extraordinary sight which greeted the crowd gathering at Leith was King George IV in a Royal Stewart tartan kilt, worn a little above the knee over flesh-coloured tights. A host of historical ironies were at work but Scott chose to ignore them all. Tartan became very fashionable, the Border textile mills

whirred and clacked to capacity, and Edinburgh was back on the royal map.

Although George IV actually slept at Dalkeith Palace, Holyrood was once again the centre of Edinburgh society as the king gave parties and held audiences. When the kilted, traditionally built head of state puffed and perspired through a few reels and jigs, the Jacobites were forgotten and the romance of Highland Scotland was born. And along Princes Street and in the Royal Mile, as it became, tartan went on sale.

Even though it was highly dubious historically and entirely bogus in some of its more commercial aspects (such as the notion of specific clan tartans), Highlandism seemed a more readily acceptable identity for Scotland than the post-union North Britain. As well as being a gifted stage manager, Sir Walter Scott was also a committed unionist. He and others felt strongly that Edinburgh needed a national monument to the

Scots who had died in the Napoleonic Wars – fighting for Great Britain. And so in the same year as George IV's visit, a call for subscription went out to fund the building of a memorial on Calton Hill. Admiral Lord Nelson already had his; the telescope-shaped tower dedicated in 1807 (its time-ball drops at 1pm precisely, allowing ships lying off Leith Roads to set their chronometers. It is also connected by a 4,000-foot cable to the One O'Clock Gun at the Castle. And on Trafalgar Day, 21st November, it runs up a naval flag signal which says, amazingly, England expects every man to do his duty). But Scots turned out to be disappointingly tight-fisted. Only £16,000 was raised, and in 1830 the project to build a national monument was abandoned, leaving 12 columns of the western facade as a monument to the wrong thing.

Finishing the western vista from Calton Hill are the three spires of St Mary's Cathedral. It is the centre-

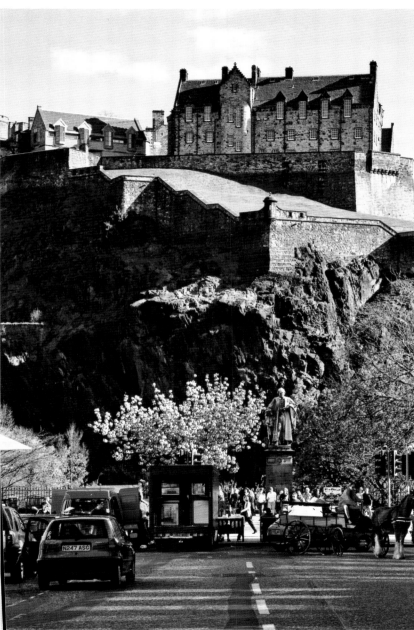

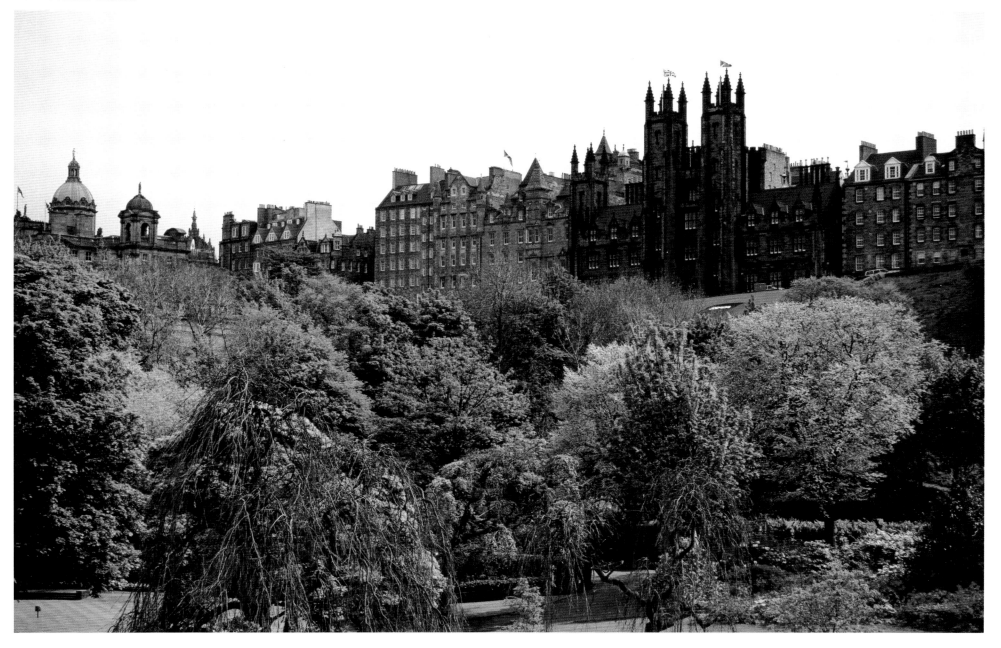

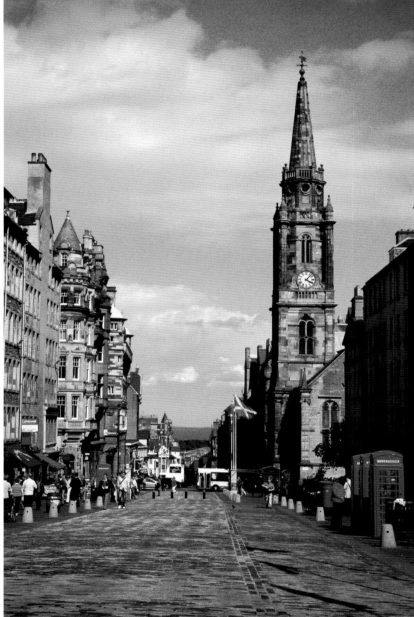

130

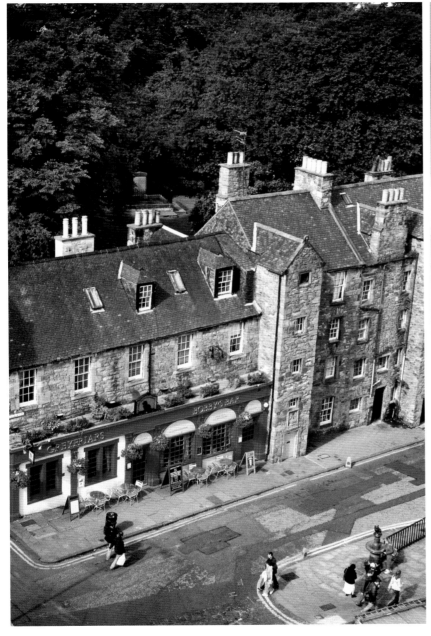

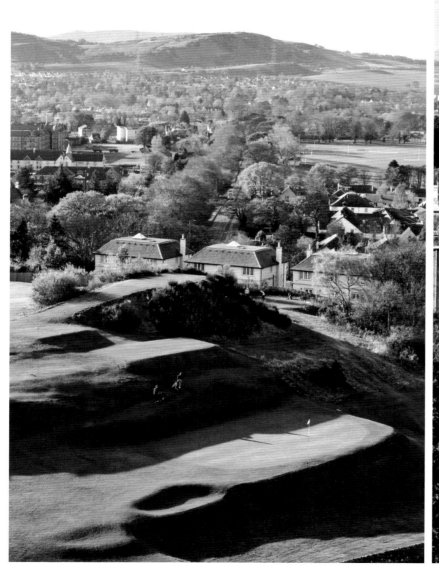

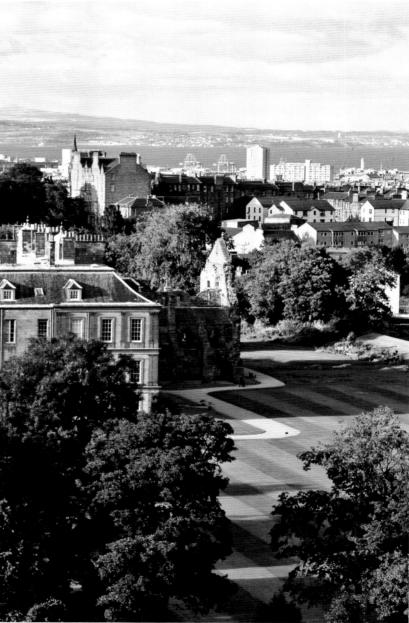

piece of the western New Town. It began development along the line of Shandwick Place and off Queensferry Street. The great church was made possible by the lucrative sale of parcels of land from the Easter Coates estate by Sir Patrick Walker. His heirs, the Misses Walker, who lived in Easter Coates House (now St Mary's Music School) in turn left his fortune to the Scottish Episcopal Church so that a cathedral could be built. Seen from Melville Street, the western New Town's axial street, their generosity is very pleasing.

God, or more precisely, interpretations of God's will, was about to send more spires soaring into the Edinburgh skyline and give the impression of an extremely devout community. In the early 19th century the Church of Scotland had been riven by ferocious faction-fighting over the issue of patronage. Who had the right to choose a new minister for the parish? Was it the congregation and its elders, or was it the laird or the

superior? By 1843 matters had boiled into a confrontation, and at the General Assembly held in St Andrew's Church in George Street, they boiled over. The Great Disruption of the Church of Scotland began with a dramatic walkout by those ministers who believed that congregations and their elders ought to take precedence over the preferences of the lairds. That bold decision left almost all of them without churches, church halls or manses, and a widespread building programme immediately began all over Edinburgh and the rest of Scotland. Perhaps its most obvious result can be seen at Holy Corner, at the foot of Church Hill, where four churches of the reformed faith glower at each other over the crossroads. A city of many spires and bell towers quickly grew up.

Perhaps the most spectacular, certainly the most widely visible consequence of the Great Disruption dominates the view of the Old Town from the north.

The Assembly Hall towers darkly over Princes Street and the New Town from its vantage point near the top of the Mound, and in its forecourt there stands a hellfire statue of the pioneer reformer, John Knox. When the General Assembly of the Church of Scotland meets in May, the ministers and elders have to file past his stern gaze.

More cheerily, Queen Victoria and Prince Albert began their love affair with Scotland in the 1840s, and by 1856 Holyrood Palace had been restored to more than its former glory. Once the Earl of Haddington had been restrained (by Act of Parliament) from quarrying the beautiful red stone from Salisbury Crags, the Queen's Park began to take shape. Using a little of the proceeds of his wildly successful novels, Sir Walter Scott employed a group of destitute weavers from the west of Scotland (notorious for its radical politics) to build the wide path at the bottom of the crags now known as the

Radical Road. And Prince Albert ordered the layout of carriage drives and the creation of Dunsapie Loch.

Much encouraged by royal patronage and the romance resonating from the worldwide success of the work of Sir Walter Scott, visitors began to make the long journey north to Scotland, and to Edinburgh in particular. A trickle grew into a flood when the railway arrived in 1846. Several lines met at the General Station at the east end of Princes Street Gardens. Very appropriately it quickly got the name Waverley after Scott's series of novels. Trinity Church was shifted southwards to make more room for platforms and the old Physic Garden moved much further north to the park now known as the Royal Botanic Garden. At first, trains departed north and east through a tunnel dug under Princes Street, St Andrew Square and emerging below Scotland Street. By 1862 another, more convenient route was excavated through Abbeyhill and the original tunnel closed up (it was used to store cars and other bulky goods until recently – and it still remains open if very spooky). With 21 platforms, Edinburgh's principal railway station was one of the largest in Britain for passenger traffic. The great railway hotels at either end of Princes Street, the Balmoral and the Caledonian, meant that passengers and their luggage did not have far to travel (there was once a Princes Street Station behind the Caledonian). Cockburn Street was driven through the closes and the backlands off the High Street to allow access to the Waverley from the south.

Between the two railway hotels stands the remarkable Scott Monument. Built in 1840–46, it is perhaps the largest and most elaborate memorial to a writer anywhere. And it is richly deserved. Even if Scott's novels and long poems are little read now, his contribution to Edinburgh and Scotland was immense. Essentially he invented the bestseller and since many of these were set in Scotland and dealt with Scotland's history, he made the country famous, far better known than it had ever been before. More people came – and brought their money, and just as important he helped add some self-confidence at a time when it was much needed. Under the blackened spire sits a sculpture of Sir Walter with his dog, Maida, at his feet. He wears the shepherd's plaid and around him, set in niches, are many of the memorable characters he created.

As more and more visitors arrived in Edinburgh, the real history of the city (as opposed to Sir Walter's clearly signalled romance) could sometimes take on a sentimental, very Victorian atmosphere. A good example of this has been immortalised in a little bronze statue of a Skye terrier which stands at the hairpin junction of George IV Bridge and Candlemaker Row. Greyfriars Bobby has come to represent kindness and canine devotion because of the famous story surrounding him.

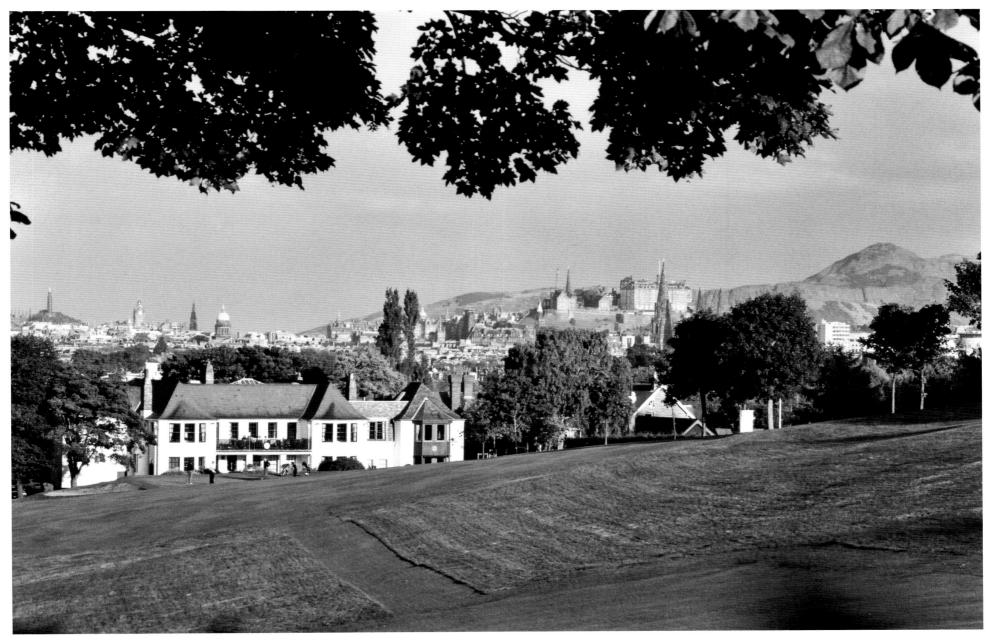

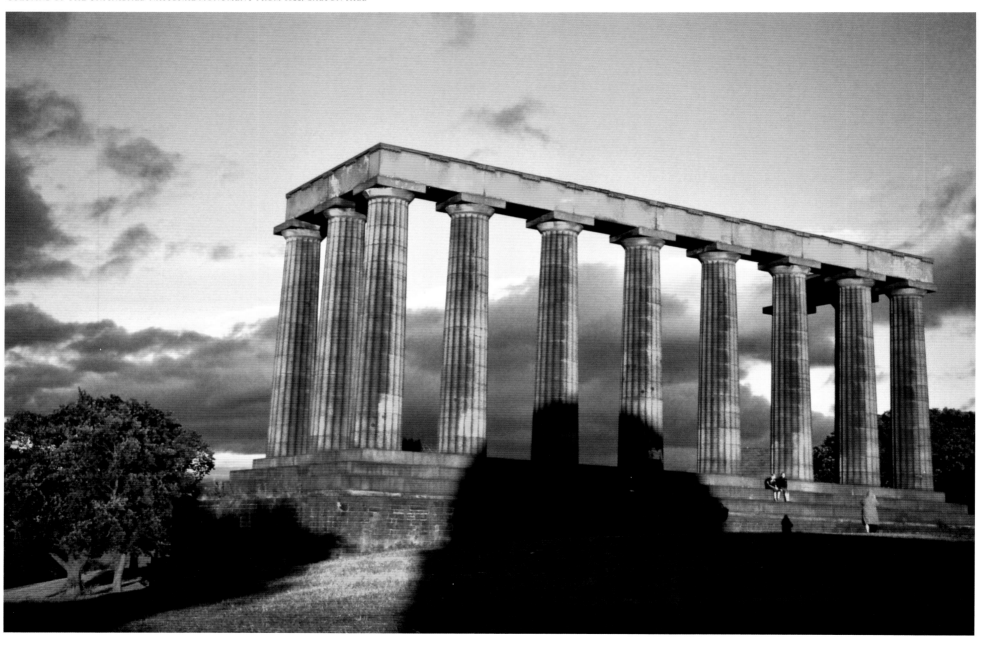

An American author called Eleanor Atkinson published it in 1912 and much later the Walt Disney Company made it into a popular film. The bones of the story were that Bobby belonged to Auld Jock Gray, a Pentland Hills farmer who walked into Edinburgh each day to have lunch at John Traill's restaurant in Greyfriars Place in the Grassmarket. The idea of that long daily journey just to eat lunch should have raised questions by itself. But it did not. The simple tale continued, and after Jock's death in 1858, Bobby carried on turning up at the restaurant every day for 14 years and the kindly owner, Mr Traill, dutifully fed him. The little dog then spent the rest of his time in Greyfriars Kirkyard, sleeping by his master's tombstone.

Not much of this is true. In fact Traill made up his own role in the story, possibly to attract customers to his restaurant. Bobby could not have arrived each day to be fed after Gray's death in 1858 because the restaurant did not open for business until 1862. And the idea that the dog could read and identify Auld Jock Gray's tomb amongst thousands of others is – unlikely. Bobby was in reality a police guard-dog belonging to PC John Gray and both of them patrolled the Grassmarket on market days to make sure that none of the livestock was stolen. When PC Gray died, Bobby lived in the kirkyard until he himself died in 1872. The residents of Candlemaker Row, who knew him when he worked, looked after the little dog and fed him for 14 years.

During the 19th century the Old Town stagnated, the great tenements off the High Street degenerating into slums. Some were unsafe and, at the north-eastern corner of North Bridge, one collapsed in 1861. It was known as Heave Awa House after another very likely apocryphal tale. When a man was found alive but buried in the rubble, he is said to have shouted 'Heave awa lads, I'm no' deid yet'. On the site the building which became that most Edinburgh of institutions, Patrick Thomson's department store, was built. PTs was one of many such shops set up in the late 19th century: Jenners may be the most upmarket and famous, but many generations of children were dragged around the January sales at R&W Forsyth's, Binns, J&R Allan's and several other endless emporia. Most have disappeared.

As the New Town crept up and over Bearford's Parks, the old Gabriel Road and the Moray Estate, and the Old Town crumbled, other housing developments pitched between these extremes found a market amongst the middling sort of people. Those who could not afford the Georgian grandeur in the north but were anxious to escape the vermin, the stink and the damp closes of the High Street began to look to the south. Across the old Burgh Loch, which opened as a public park in 1860, new, modern, spacious tenements began to rise.

Sir George Warrender of Lochend owned much of

the old Burgh Muir and had built himself Bruntsfield House. It now forms the core of James Gillespie's School. In 1850 he decided to lease substantial parcels of land for housing and by 1869 plans had been drawn up. As the plots were pegged out, Warrender made two conditions: the streets had to be named after branches of his family and their estates (most of these have Berwickshire connections – Marchmont, Lauderdale, Thirlestane and others) and that no shops should sell alcohol. The latter did not last but there are still very few pubs in the area.

It was a huge scheme, rivalling the New Town, and the tenement flats proved very popular. Plaques on some of the facades offer a clue as to how the business of development was managed. Builders and architects built piecemeal and speculatively – not entire streets but only a few plots at a time and when the tenements had been completed, they then sold them, and left their initials as a memorial to enterprise. For example ABC is the Argyle Building Company in Argyle Place, EC is Edward Calvert and Co, and so on.

Most of the suburb which became known as Marchmont, after the main thoroughfare, was completed by 1914. And elsewhere in the inner city extensive tenement development took place, particularly in Tollcross, Bruntsfield and either side of the arterial roads towards Dalkeith and the Borders. Unlike London, Edinburgh splits more decisively into north and south rather than east and west. Princes Street is the frontier between New Town formality and Old Town and Southside sprawl. The residents of the Grange, Church Hill, Morningside and Merchiston and other upmarket enclaves might object but the divide is broadly accurate.

Gorgie and Dalry developed industrially as well as places to live, and in the west some of Edinburgh's characteristic products were manufactured. Sometimes reeled off as the Three Bs, that is, beer, biscuits and books, the companies making these thrived in the later 19th century. What first encouraged factories and warehouses in the west of the city was the digging of the Forth and Clyde canal in 1818-22, and then the approach of the railway from the same direction. Before 1940, Edinburgh boasted 20 independent brewers, and as late as the 1980s, the powerful aroma of malting barley blew over the city. But brewing in Edinburgh has seen a steep decline in the last 30 years. Many famous publishers, printers and papermakers were sustained by the city's schools, university and the needs of the legal and medical trades. And for many decades McVitie's and Crawford's baked excellent biscuits. Some vestiges of each industry remain, but by the end of the 20th century the service sector employed four out of every five people in Edinburgh.

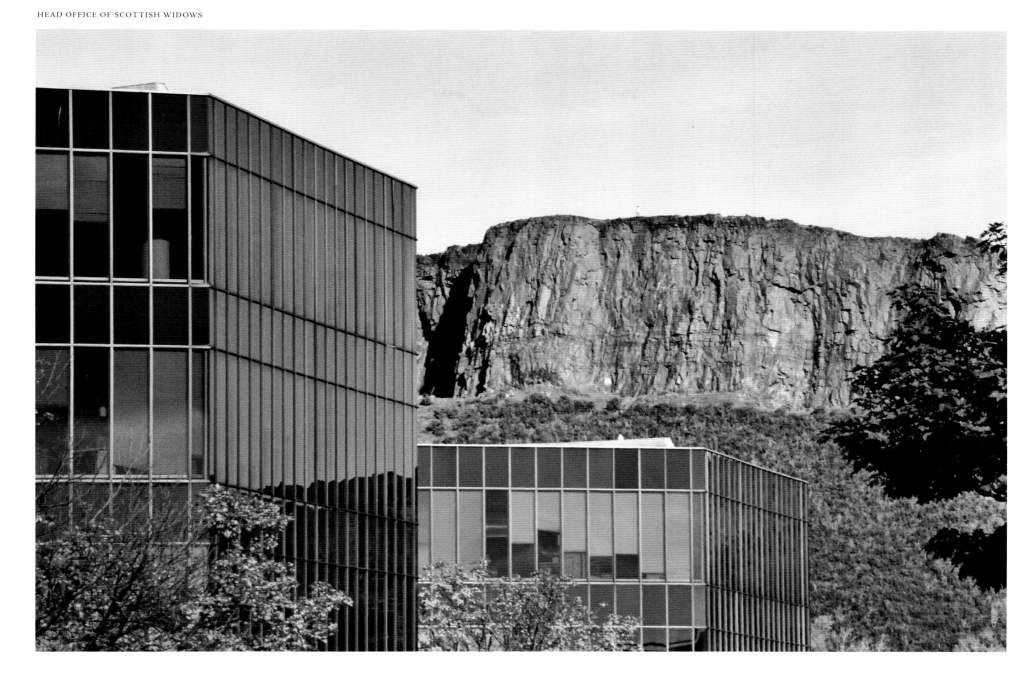

By 1919 an act of Parliament had ordained that Leith should become an integral part of the city. Leith was not happy and evidently an impromptu referendum polled only 5,000 votes for incorporation and 29,000 against. But an act needed to be enacted, the union was enforced and other uses had to be found for Leith's municipal buildings. Halfway up Leith Walk the Boundary Bar remembers where it ran – and that there was one.

In the late Victorian period Edinburgh had industrialised and expanded, but the identity of the city appeared to drift. Having lost a parliament entirely, regained only temporary royal significance (at least once a year), and being the headquarters of the Church of Scotland and the centre of the separate legal system, it retained some occasional sense of a capital city. But its dramatic setting, the dominant castle, and its stately and beautiful architecture all appeared to be a wonderful stage set for a play which was never performed. Power, real power was not often to be found in provincial Edinburgh.

The government post of Scottish Secretary had been made a cabinet rank appointment in 1892, but the Scottish Office was in Dover House in London. After World War One, and the success of the nationalist movement in Ireland, the political weather began to change. In 1926 the Scottish Secretary became the Secretary of State for Scotland and by 1939 his department had come to resemble a government in miniature with sub-departments of home affairs, agriculture, education and health. And in the same year the Scottish Office came home when St Andrew's House was opened on the southern flank of Calton Hill, on the site of the old jail.

It is one of the most beautiful buildings in Edinburgh, a masterpiece of 1930s architecture and design – and yet it is little visited. Influenced by the Art Deco movement, some of the interiors are opulent, especially the suite of offices for the Secretary of State. On the north-facing frontage superb sculpture surrounds the entrance with allegory and the appropriate motif of the Scottish thistle.

Despite the fact that its opening was submerged in the outbreak of war in September 1939, this building and what it represented at last drew Edinburgh out of the drowsy nostalgia Scotland had dozed through in the previous hundred years. Power had returned – and more was to come.

After the Second World War, like the rest of Britain, Edinburgh found itself making do and mending in the austere aftermath. Following the sacrifices and tragedies of war, its cost continued to impoverish. The victors often complained that they felt like the defeated as the Americans in particular extracted all that Britain

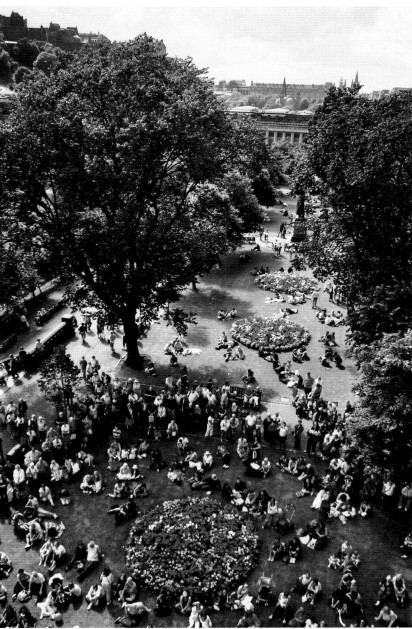

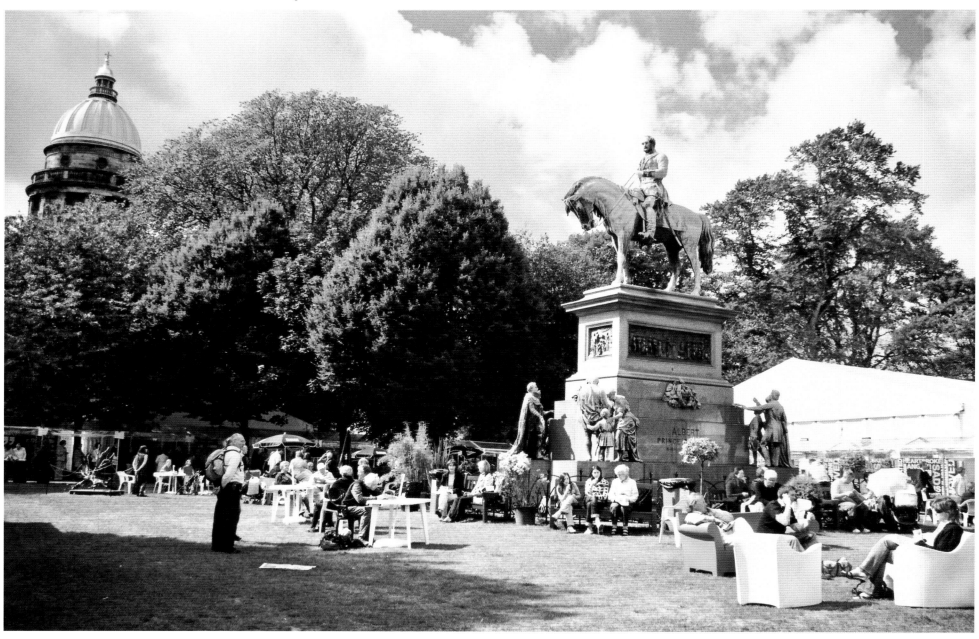

owed after the mighty and expensive efforts of 1939-45. But in Edinburgh some light quickly flickered in the grey skies. Rudolph Bing, who ran the Glyndebourne Festival Opera, wanted to see an arts festival founded in Britain, something like the great classical music festivals he knew at Bayreuth and Salzburg. After failing to interest the city fathers in London, Oxford or Cambridge, Bing came north to meet Edinburgh's Lord Provost, Sir William Falconer, who, to his undying credit, embraced the idea, put in a little municipal money and a great deal of encouragement.

The Edinburgh Festival was an immediate success. Rudolph Bing's excellent European contacts produced a first-rate classical music programme for the premiere in August 1947. And the sun shone. Edinburgh basked in a glorious summer and crowds came out to the events in large numbers. The prior generosity of the brewer, Andrew Usher, enabled the Usher Hall to become the focal point for orchestral concerts and other recitals. Glamour, show business, opening nights, divas and conductors, black tie and evening gowns – all of these lit the gloom of the post-war years in Edinburgh – and Scotland.

Something unexpected happened at the first festival in 1947, something which made the Edinburgh Festival absolutely unique and over the following 60 years would transform the city's image. Eight theatre companies turned up to perform in the August of 1947. They were not in the official programme and no-one had invited them. But nevertheless productions of *Macbeth*, *Murder in the Cathedral*, *The Anatomist* and six other plays were mounted and drew healthy audiences. One critic called these groups Festival Adjuncts. More came in 1948 and mercifully the playwright, Robert Kemp, christened this phenomenon as the Festival Fringe.

By the early 1980s more than 500 groups crammed into the city and every performing art form was represented, from comedy to dance to puppetry. The Fringe has now swamped the official festival but in so doing it has brought the city alive in the summer. Using all of those church halls built after the Disruption, and many other spaces, it reaches all over Edinburgh, and since street theatre and music was finally permitted in the late 1970s, the colour and racket of celebration has spilled all over the central streets and open spaces. The crammed-together, cellular nature of the Old Town has nurtured the Fringe, its old halls and meeting rooms being perfect for small-scale performance. The combined Edinburgh festivals (books, jazz and film) are immensely lucrative, bringing in many millions of pounds, and it has also made Edinburgh internationally famous, the name a byword for innovation in the arts. As theatre-goers rush past him to catch performances in the Assembly Hall on the Mound, John Knox appears

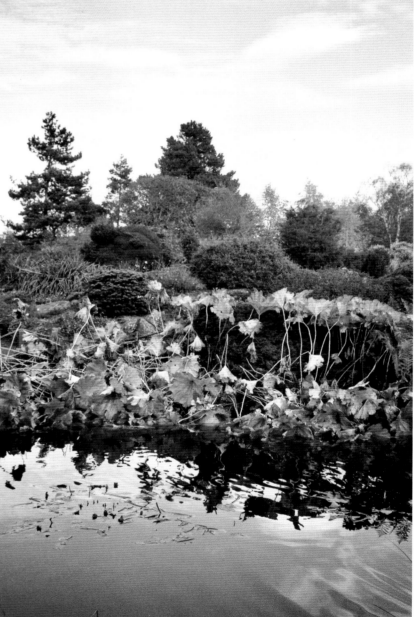

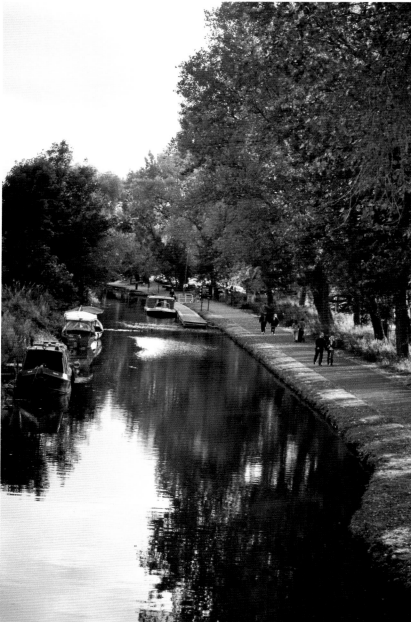

no longer to thunder, but falls strangely silent, at last.

After the Second World War, the Festival was not the only radical innovation to affect the city. In 1949 Professor Patrick Abercrombie promulgated a series of planning proposals which ultimately transformed Edinburgh – even though not all of them were carried through. Fundamental was the creation of large estates of public housing on the outskirts. These would relieve the overcrowding and poor living conditions in Gorgie, Dalry, Leith, Portobello, Pilrig and the Pleasance and also allow redevelopment once these rundown inner city areas had been cleared. The New Jerusalem was promised. Houses with inside toilets, baths and efficient heating were quickly added to those built in the 1930s at Craigmillar, Piershill and Saughton. Vast new schemes went up at Drylaw, Muirhouse, Gilmerton, Oxgangs and Wester Hailes. Living conditions seemed at first a great improvement on the rickety, poorly serviced tenements

of the Old Town and inner city. But two difficulties soon came to light. The need to build quickly, cheaply and in volume had in some places produced lower standards than the new residents either expected or deserved. Condensation, noise pollution and dampness affected many.

The planners had also failed to take sufficient account of what common amenities these new communities might need. In the Old Town and its fringes, pubs, shops, and small service businesses such as cobblers and repairers of other sorts had grown up with local demand and custom. Churches and church halls were still focal points. There were certainly public parks in the new estates and small parades of shops, but mostly the ranks of grey-harled streets marched on unrelieved. And in such large communities, the informal mechanisms of social control which could operate well in tenements and closes were quickly overcome by those

with little interest in thinking of their neighbours. By the 1970s many of the peripheral estates looked forlorn. Houses were sometimes simply abandoned and boarded up, particularly at ground floor level, and the public spaces left to rot. A drug culture spread like a disease, and Edinburgh acquired an unwelcome reputation as shoot-up city.

For the historic centre Professor Abercrombie and his supporters planned aggressively modern development. Fifty years before, Professor Patrick Geddes had also wished to see changes, in the Old Town in particular, but his views were different. He had the house of Allan Ramsey, the artist, extended and remodelled. In what came to be called Ramsey Garden, rooms for Edinburgh University students and private flats were built in the 1890s. The result is magnificent, an organic development clinging to the edge of Castlehill and the Esplanade, entirely in keeping with the Old

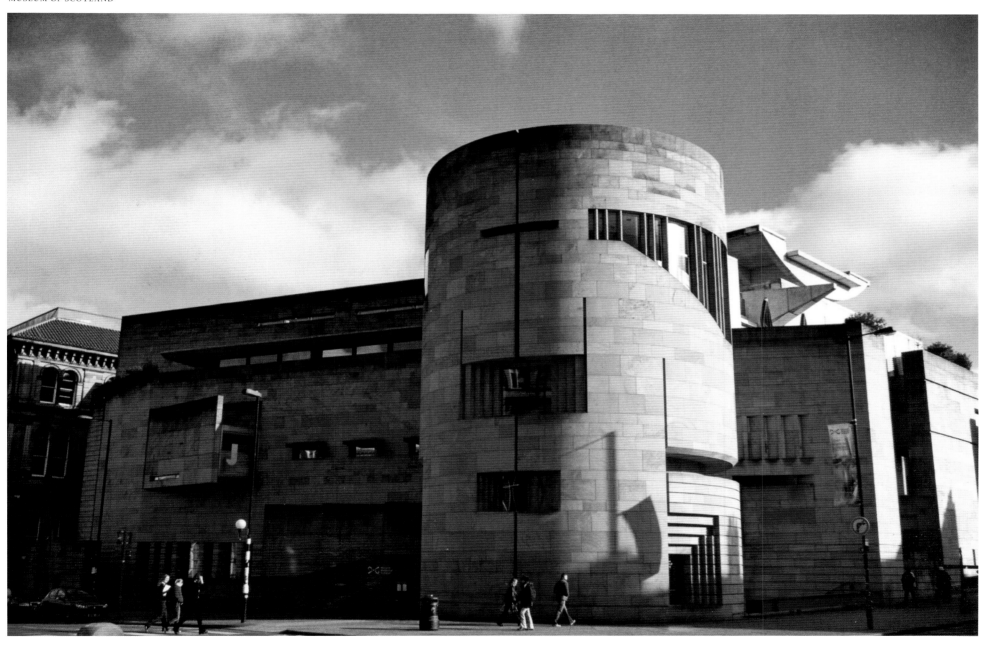

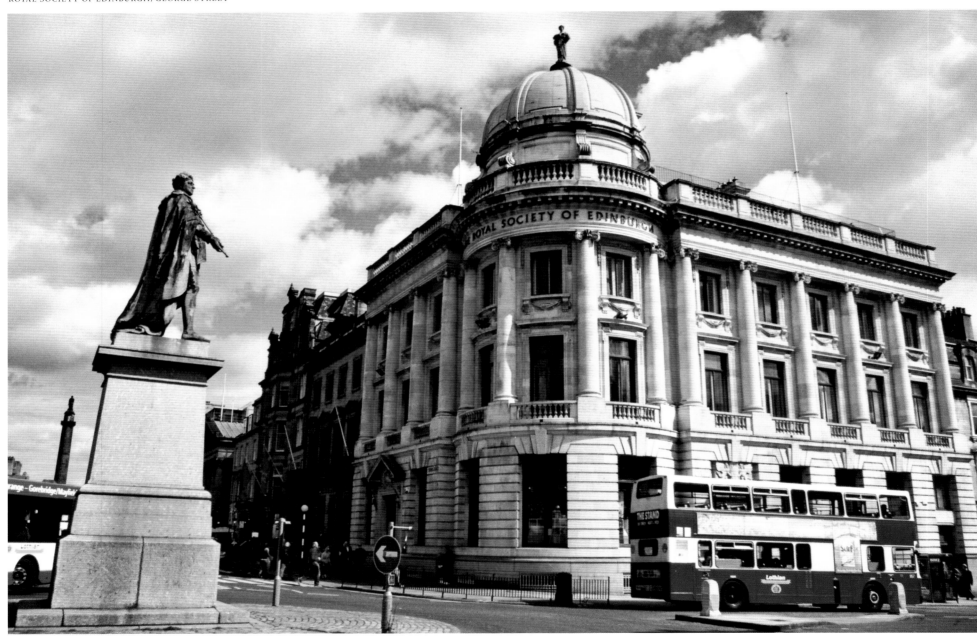

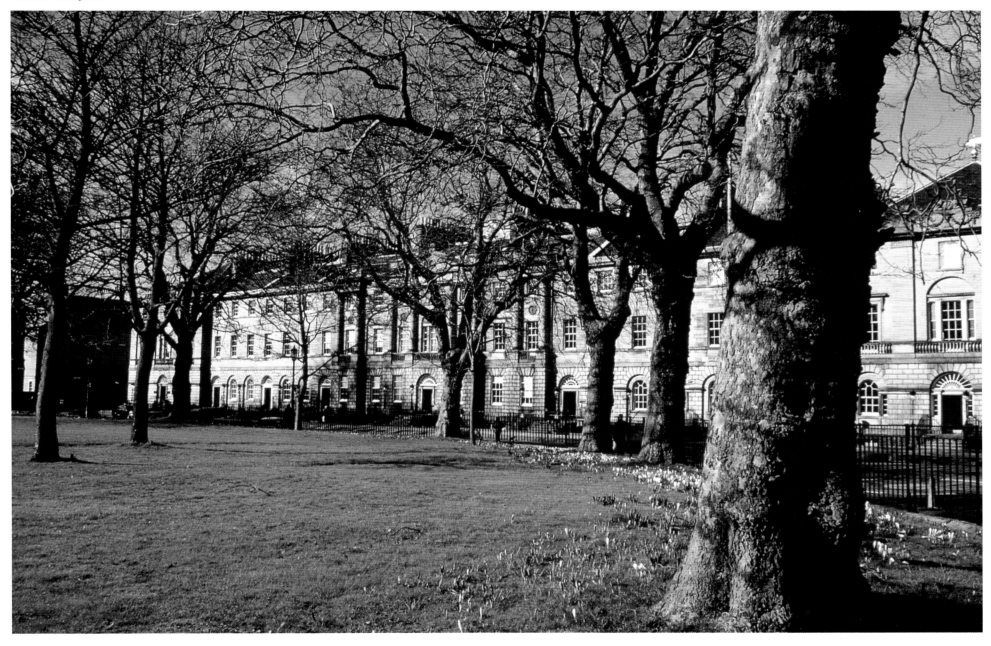

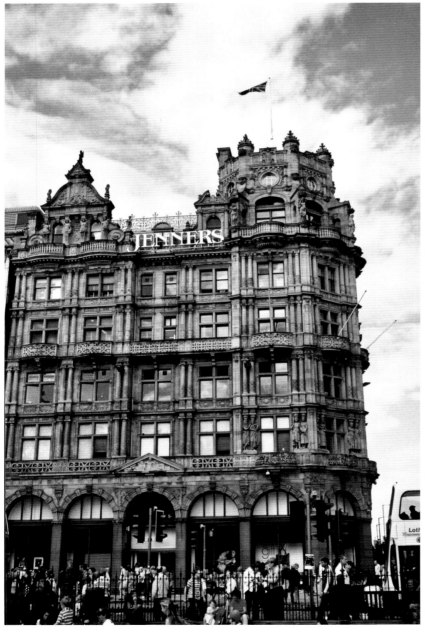

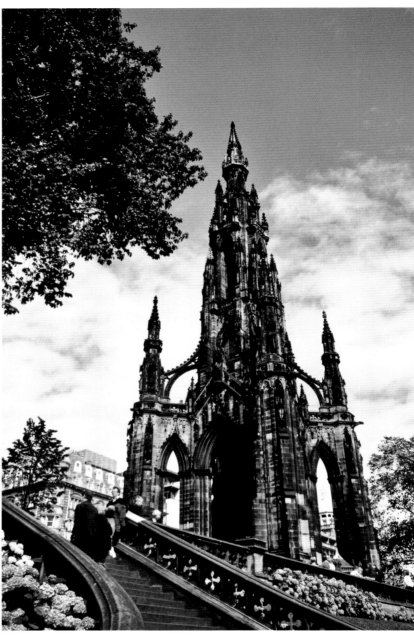

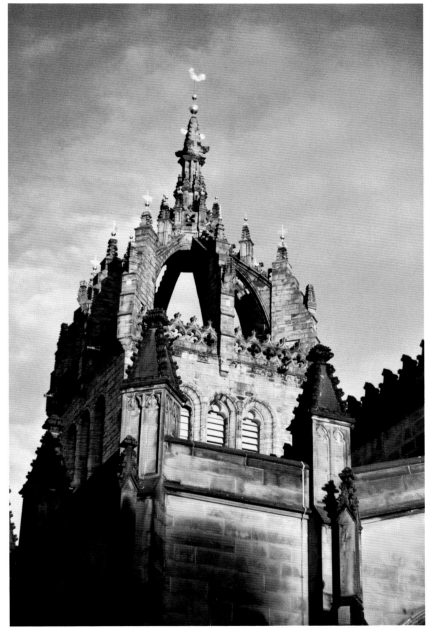

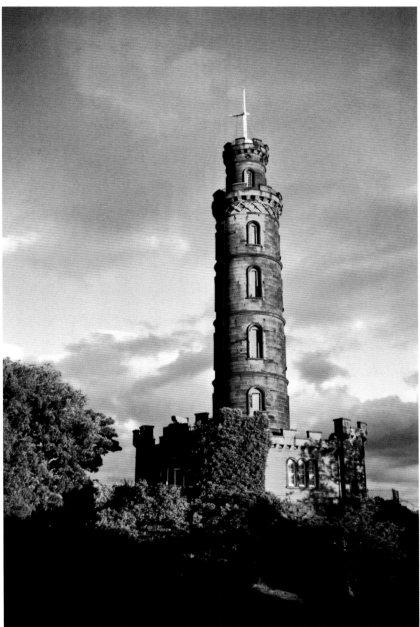

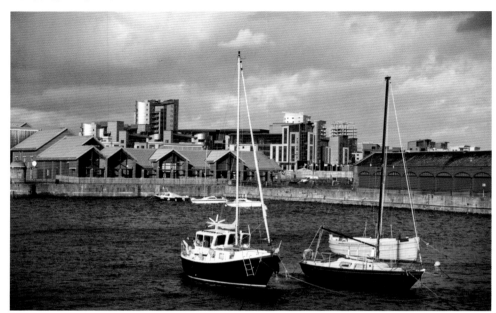

NEWHAVEN HARBOUR

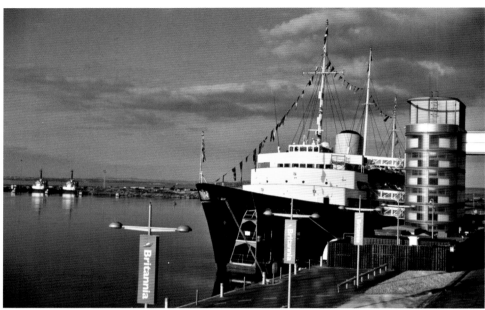

ROYAL YATCH *BRITANNIA*

DYNAMIC EARTH, HOLYROOD PARK

HEAD OFFICE OF *THE SCOTSMAN*

Town, and a highly visible adornment to the city. What Edinburgh University planned in the 1950s and the 1960s was to be far from sympathetic.

The core idea was straightforward enough and could have been appealing. As the tumbledown rookeries of the Southside decanted their residents to the outlying estates, Edinburgh University would be encouraged to create an academic enclave centred on George Square, the MacEwan Hall, the Reid School of Music and the Medical Faculty next to the Royal Infirmary. But the planners planned to be ruthless. Criminally, much of George Square, the earliest example of Georgian town planning in the city, was demolished to make way for undistinguished modern towers, with no ivory to be seen, and the well-designed new university library. North of George Square, the Parker's Triangle was entirely effaced and replaced by a temporary car park. Bounded by Charles Street, Potterrow and Crichton Street, the Triangle was named after Parker's Stores, an excellent emporium selling goods at discount prices. Charles Street was particularly notable with well-set Georgian tenements and the Paperback Bookshop. It housed performances during the Festival Fringe and its management helped create the Traverse Theatre in 1962. Just as Edinburgh University succeeded in having all of these homely and interesting streets erased, it appeared to run out of the money needed for the building projects planned for the site. The temporary car park remained in place for a disgraceful 40 years.

Elsewhere the developers at least managed to replace what they had destroyed. Notably, the appalling St James Centre, a shopping mall, was planted on the site of St James' Square, Georgian housing to the east of St Andrew Square. Irony took a hand when the demolition crews dumped the rubble into Craigleith Quarry. Much of the stone for the New Town had come out of it in the late 18th and early 19th centuries.

The greatest threat from so-called modernisers was the project known as the Inner Ring Road. As it tunnelled under the Old Town and roared through the Meadows, it would have devastated much of the historic city. Conservationists finally rallied and rose up against the scheme, and after a public enquiry in 1967, it was abandoned.

As often throughout its long history politics began once more to stir and begin to re-shape Edinburgh. In the 1970s the Scottish National Party broke through into the mainstream and forced the Labour and Conservative parties at least to have policies rather than attitudes to home rule. Labour had become the political establishment in Scotland (even Edinburgh had Labour Lord Provosts) and in order to contain the SNP as well as meet the wishes and expectations of their own

supporters, the Callaghan government agreed to a referendum in 1979. Yes and No campaigns debated vigorously but the intervention of a London MP proved determinant. A simple majority in favour would not be enough, at least 40% of the electorate had to vote Yes for there to be what was then called a Scottish Assembly. Despite this, the portents were favourable and the Old Royal High School building (the RHS had decamped to a new site in Barnton) was converted into a debating chamber and offices. It lay handily near St Andrew's House.

It was not to be needed. When the results came in, they showed a majority in favour of devolution for Scotland, but it fell short of the 40% and the proposed bill therefore fell. Edinburgh would not have a new parliament after all, and the debating chamber gathered dust, empty and unused.

Almost immediately the mood appeared to change.

While Scotland voted mostly Labour in successive general elections, England chose the Conservatives and as Prime Minister, Margaret Thatcher. Instead of withering after the disappointments of 1979, support for Scottish devolution began to harden, much encouraged by what came to be known as The Sermon on the Mound. In 1988 the General Assembly of the Church of Scotland invited Mrs Thatcher to give an address. She announced that the church existed to promote personal redemption and not social reform and that, incidentally, there was no such thing as community. These contentious views and her quote from 'I Vow to Thee My Country', a hymn not included in the Scottish hymnary, were greeted by a polite scatter of applause. Mrs Thatcher was then thanked by the Moderator, the Reverend Professor James Whyte. Without a flicker, he gave her two pamphlets which he hoped might interest the Prime Minister. One was concerned with justice,

fairness and poverty in society and the other dealt with issues relating to public housing.

Despite Margaret Thatcher's polarising unpopularity in Scotland, devolution and a parliament would take another ten years to come. It required the landslide Labour victory of 1997 and a majority in a subsequent referendum for the Scottish Parliament to reconvene at last in 1999. Yet more irony unfolded as temporary premises were found in the Assembly Hall on the Mound. MSPs were elected, trooped past Knox's statue and took their places in the chamber. It was only appropriate, for the Church of Scotland had remained a bastion of Scottishness for the three centuries when there was no parliament in Edinburgh.

In the first elections the Labour Party gained the largest number of seats, but not an overall majority and was forced to form a coalition with the Liberals. Donald Dewar became First Minister. It seemed that a new

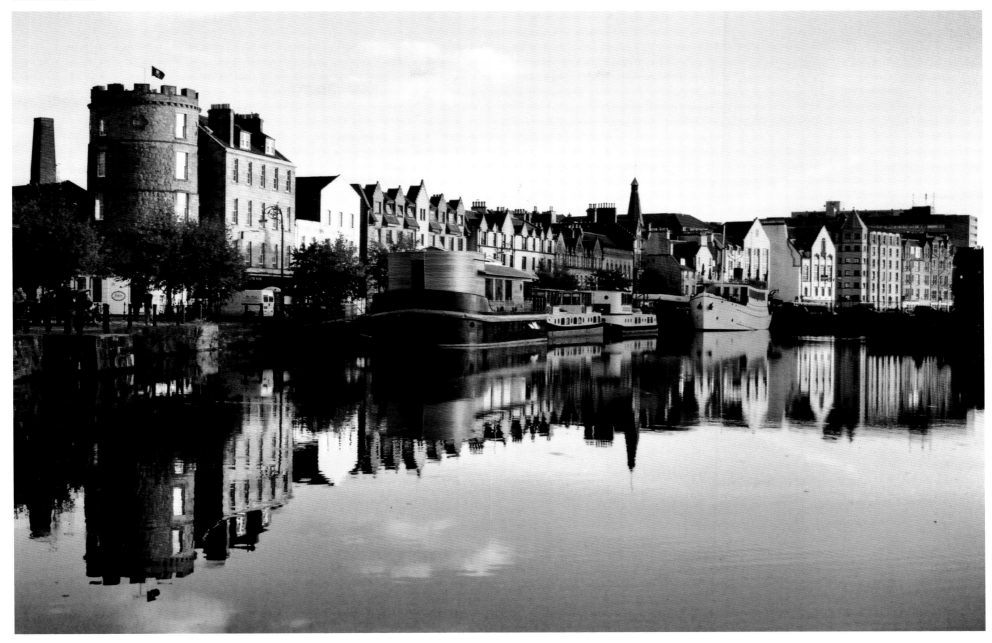

politics and a new beginning was at hand, but instead the entire project became mired in a controversy which threatened at least to distract, even to derail the devolution settlement in its infancy.

In 1998 Holyrood had been chosen as the most appropriate place for the new parliament building and not the old Royal High School at Calton Hill. Soon after the rejection of devolution in 1979 a vigil began at the gates of the old school and it may have been that the building was too closely identified with the SNP and the controversies of the past. Scottish Labour politicians in particular argued that the accommodation was outdated, the rooms too restricted and too small. The fact that the old Royal High lay very close to St Andrew's House seemed not to matter at all. And so Scottish and Newcastle breweries sold their site at Holyrood, moved out and work began on demolition.

Meanwhile an architectural competition was advertised to find the right design. Enric Miralles, a Catalonian architect, won and his very different, very bold concept went on display. Costs began quickly to spiral and became the cause of justifiable outrage. As they climbed towards an astonishing £414 million, there was a danger that the Scottish public would lose sight of the purpose of the parliament and lose respect for MSPs. It seemed that far from running the country, they were unable to control the spiralling costs of their own building.

For £414 million Edinburgh and Scotland bought a strange piece of architecture. The exterior appears both cluttered and fussy as well as oddly arranged and difficult to read. But the debating chamber is nothing short of a triumph, a beautifully handled space which impresses but does not overawe. Grey concrete is the primary and very dull finish, but here and there wood, metal and stone enliven. The Scottish Parliament seems like a building which came from nowhere, likely to date quickly, and despite much appropriate detailing, not particularly Scottish in its feel.

The impact of the fact of the parliament on Edinburgh has nevertheless been electric. Not only has the Canongate and Holyrood bloomed into life as media outlets cluster and new hotels are opened, but also the whole local Edinburgh economy is booming. Power attracts business and business brings investment. Edinburgh feels like a capital city, dynamic and adaptable. The new hotels buzz with conferences and the meetings of busy people anxious to work close to the new parliament and its politicians and civil servants. And the great city supplies a rich setting for all of that bustle and hustle, making the centuries between 1707 and 1999 seem like a hiatus. At the outset of the 21st century Edinburgh is Edinburgh again.

♦ ♦ ♦

The fact that Edinburgh is the most beautiful city in the world is not just a matter of subjective judgement, it is also demonstrable. Geology, architecture, history and accident all combine to make it unique, a combination of characteristics found nowhere else.

Many cities are built on the banks of wide rivers, like London and Paris, and that usually means a flat site where buildings, streets and public spaces dominate. While many are very beautiful and impressive, there is often a powerful sense of enclosure, with few long vistas. Because it is built on hills and ridges, Edinburgh is different and easy to see out of, to see the city in its setting. And there are two quite different aspects to be enjoyed. From many not particularly elevated places, such as the junction of George Street and Hanover Street, there are very pleasing views of the sea, the Firth of Forth, the Fife coastal towns and the hills beyond. To the south rise the green heads of the Pentland Hills.

These are everyday sights, but from the Castle and the Esplanade the views are breathtaking, leading the eye away into the distance on every side.

Inside the city there is more drama. Geology carved out the canyon of the Cowgate and from George IV Bridge and South Bridge the descent is dizzying. On the northern flanks of the High Street, the sharp fall of the ground makes buildings like the Bank of Scotland Head Office and the Assembly Hall appear impossibly monumental. The long incline of Leith Walk leads to the port and the sea beyond. From the suburbs it is almost always possible to see the Castle Rock and the centre of the city – making it difficult to feel lost.

Edinburgh is not large and anonymous. Despite the expansion triggered by the presence of the parliament, the population of half a million or so seems comfortable. Enough to justify everything a city might have to offer but not too large to prevent enjoyment of

galleries, theatres, sporting arenas, cinemas – even during the festival the pavements are manageable and public spaces allow escape from the crowds.

Perhaps the best place to see it, to consider and enjoy the character of the beautiful city and watch it bustle is also one of the most frequented. From Calton Hill, on a summer evening, the view along Princes Street is eloquent. Edinburgh lies below in all its richness, all its vitality and all its ancient glory.

DEBATING CHAMBER, SCOTTISH PARLIAMENT

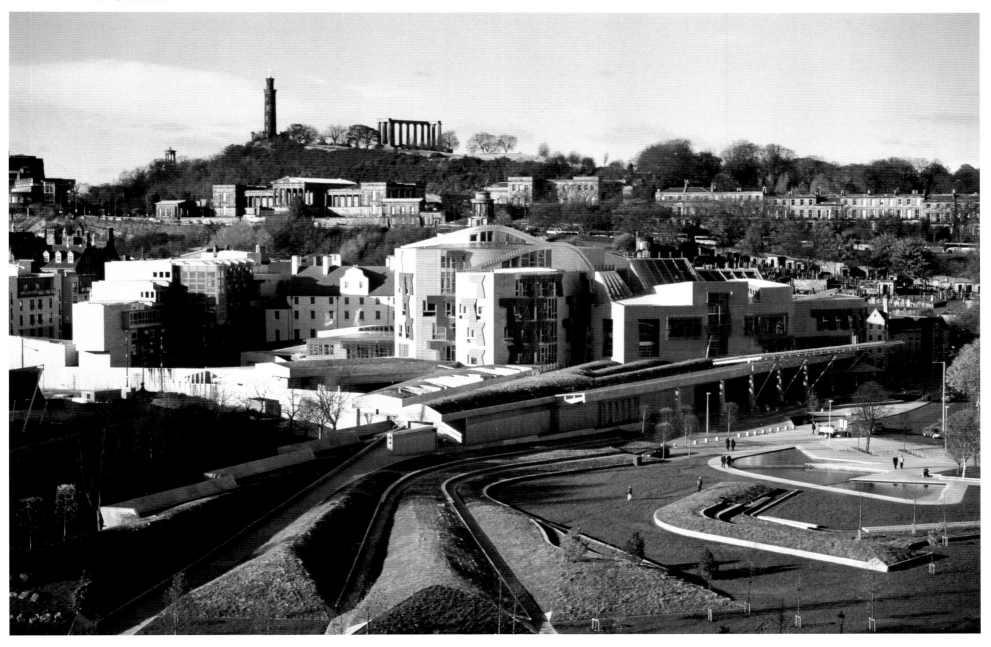

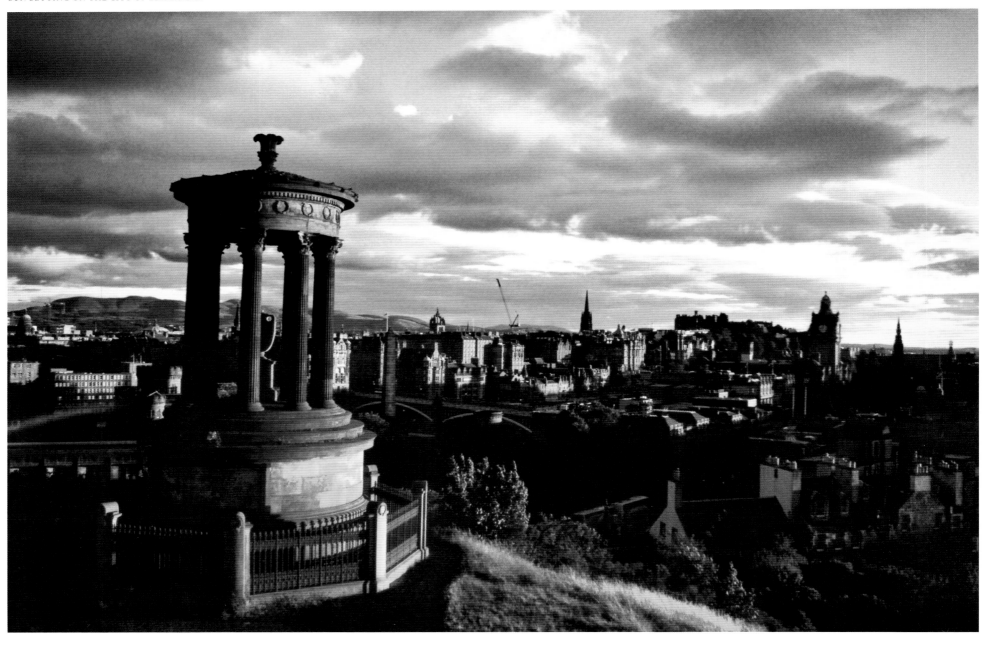